IMAGES
of America

PARAMOUNT STUDIOS
1940–2000

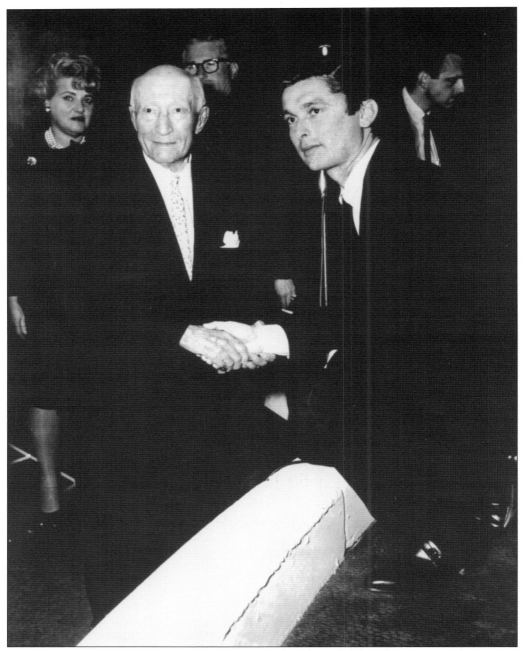

ADOLPH ZUKOR AND ROBERT EVANS. Paramount founder Adolph Zukor greets Robert Evans at a 1967 press conference announcing the appointment of Evans as Paramount Pictures head of production.

ON THE COVER: This photograph shows the Windsor Gate, as it appeared in 2000. (Photograph by Michael Christaldi.)

IMAGES
of America

PARAMOUNT STUDIOS
1940–2000

Marc Wanamaker, Michael Christaldi,
and E.J. Stephens

Foreword by Robert Evans

ARCADIA
PUBLISHING

Published by Arcadia Publishing
Charleston, South Carolina

Printed in the United States of America

Library of Congress Control Number: 2015944923

For all general information, please contact Arcadia Publishing:
Telephone 843-853-2070
Fax 843-853-0044
E-mail sales@arcadiapublishing.com
For customer service and orders:
Toll-Free 1-888-313-2665

Visit us on the Internet at www.arcadiapublishing.com

For Angela, who will someday write a better book of her own

—Michael Christaldi

To Hollywood Heritage and the Lasky-DeMille Barn, where it all began

—Marc Wanamaker

To Paramount Pictures, for giving us over 100 years of great memories

—E.J. Stephens

CONTENTS

FOREWORD

American film is the only product made in this country that is number one throughout the world. It flies the American flag higher than any other export. Our industry deserves respect for that, and I for one am proud to be part of it.

Darryl Zanuck once told me if you can tell a story in a paragraph, you have a hit. If you can tell it in a sentence, you have a blockbuster! That very well might be true, but I can tell you with certainty that if it ain't on the page, it ain't on the screen. The property is king. That being said, filmmaking is essentially a collaborative effort.

This is a dynamic industry that is constantly in flux. Paramount has always made the moving picture, but the business of filmmaking changes from decade to decade. In the 1960s, the industry had been in decline for some time. It was losing money and finding it hard to relate to its new, younger audience. Many of the studios had already changed hands earlier in the decade, and Paramount was one of the last to make that generational leap. After Gulf + Western bought Paramount in 1966, Charles Bluhdorn approached me to run the studio. The status quo had been swept away, so we were given unprecedented freedom to revolutionize our product. Our approach was to use new or untapped talent to find a fresh voice that would speak to our changing audience. We set out to find the romance of the moment and to tell stories about "how it feels."

A studio is a constantly creating artist's workshop. Whether it be the cinematography, writing, directing, or acting, all of these things become pawns for those who control the magic of post-production. "Dailies" are the takes selected by the producer, director, and cinematographer. They examine and cull out the best of the previous day's filming. The director, being the captain of the ship, picks out his choices for the editor to assemble. Post-production is the most important element in the anatomy of filmmaking. It is an art unto itself and structures the arc of your story. Film, dialogue, sound, music, and effects are its five major tentacles, and during the post-production process, each of these are structured and edited separately by highly talented artists—whose contributions are rarely appreciated or spoken of. Frame by frame, with precision and skill, your canvas evolves its persona. Post-production is a key to film magic or film mediocrity. From it comes your completed canvas, which is presented for all of the world to see and critique.

Paramount was the first studio to make a full length feature film (*Queen Elizabeth*, 1912). Now, 103 years after its founding, it is the only major studio left in Hollywood, and under Sumner Redstone's vision, it is stronger and more productive than ever. Looking through this book of wonderfully evocative photographs with Michael Christaldi, it naturally brings many personal memories to mind. Perhaps you could think of them as not just photographs of what was, but as a record of what still is . . . In a different time.

Robert Evans
June 12, 2015
Beverly Hills, California

ACKNOWLEDGMENTS

First and foremost, we would like to thank Robert Evans for taking the time to write the foreword for this book. In the 1960s, he brought Paramount out of the ashes and restored it to prominence. Without his foresight, this would be a much shorter read.

The authors would like to thank everyone at Arcadia Publishing for their hard work, especially Lily Watkins, Jeff Ruetsche, and David Mandel.

At Paramount Pictures, we would like to thank Jan Marie Johnson and her staff in guest relations: Kathy Coulter, Amy Lowry, Koranda Banks, Braden Yandle, Patrick Nicely, and Paramount's former guest relations managers Josh Jack and Bob Greg. Thanks also go to Jaci Rohr and Randall Thropp at Paramount's archives; Aaron J. Segal at the Water Tower; and Paramount's administrative concierge Kimberly Denny Pucci for her enthusiasm and help. And last but not least, thanks to the keepers of the gate, Paramount Security guards Mike Olguin and Nino Cicinelli for all their help and support.

Marc Wanamaker wishes to thank his coauthors, Michael Christaldi and E.J. Stephens, for their work and knowledge about Paramount's history. Thanks also to the Hollywood Heritage Museum and to Tommy Ryan for his rare photos. The authors thank Bison Archives for supplying most of the historical images for this book, which is a continuation of 2013's *Early Paramount Studios*.

Michael Christaldi: I would like to thank my daughter, Angela, for the million things she does to make me proud. Thanks go to my parents, Mario and Annamarie, for their constant love and support, and to my cousin Antonio J. Tronco, who is no longer with us but always believed in me and would have been proud to read this. I would also like to personally thank Robert Evans for taking the time to invite me into his home to work on this project. Most people never get to meet their idols, so it is a real thrill to be friends with mine. Thanks, Kid . . . I owe you one! Also, a big thank you to The Robert Evans Company's head of production, James Sikura, for being a friend; Alan Selka, for all his hard work and knowledge; and Michael Binns-Alfred and Alex "Rio" Bier for their assistance.

E.J. would like to thank his out-of-his-league wife, Kimi, for all of her love, support, and brilliant editing. He also wants to thank his kids, Mariah and Dylan, for their kindness, curiosity, humor, and overall awesomeness.

Unless otherwise noted, all photographs were provided by the Bison Archives and the Christaldi Collection.

INTRODUCTION

The turbulent Great Depression of the 1930s blighted the American economy and left the wreckage of entire industries in its wake. Hollywood, which many observers believed to be "Depression-proof," felt the devastating effects just as much as any other company town—with the fallout affecting both stalwarts and startups.

This was especially true for Paramount Pictures, which most often found itself jockeying for the lead position in the race for Hollywood supremacy during the two decades since its creation. The studio was the child of several fathers, primarily Adolph Zukor, Jesse L. Lasky, Samuel Goldwyn, and Cecil B. DeMille. By the mid-1930s, it was guided by a new set of chiefs, after Lasky was ousted, Zukor moved upstairs to the chairman's office, and DeMille had been relegated to serving as a directorial hired hand. Paramount appointed Barney Balaban president in 1936, with Y. Frank Freeman installed as head of production two years later.

Then, like now, talent drives Hollywood, and Paramount enjoyed a galaxy's worth of stars during the 1940s. This impressive array included Ray Milland, Claudette Colbert, Barbara Stanwyck, Fred MacMurray, Bing Crosby, Dick Powell, Dorothy Lamour, Bob Hope, Gary Cooper, Paulette Goddard, Fredric March, Fred Astaire, Jack Benny, William Holden, Veronica Lake, Olivia De Havilland, Henry Fonda, Joel McCrea, Alan Ladd, John Wayne, Ginger Rogers, Cary Grant, Danny Kaye, Marlene Dietrich, Jane Russell, Victor Mature, Burt Lancaster, and Hedy Lamarr.

Some of the studio's most notable films released during the 1940s included *Arise My Love*, *Northwest Mounted Police*, *The Lady Eve*, *This Gun for Hire*, Billy Wilder's *The Major and the Minor*, *Reap The Wild Wind*, *The Heiress*, *Chicago Deadline*, *The Great Gatsby*, *Bride of Vengeance*, *The Road to Morocco*, *So Proudly We Hail*, *Hail the Conquering Hero*, *The Miracle of Morgan's Creek*, *Double Indemnity*, *Samson and Delilah*, and the Best Picture winners *Going My Way* and *The Lost Weekend*.

In 1948, Paramount was found guilty of antitrust violations and was ordered to dispose of its theater chain. The studio responded by investing heavily in the medium of television. Chairman Adolph Zukor believed at the time that, since most Americans did not own a television set, people would actually go to the theater to see television programs.

By 1957, there were over 40 million American television sets. To counter this threat, the studios developed new forms of film presentation for their theaters. This began with Fox's CinemaScope, which was later copied by the other studios, including Paramount's VistaVision—which employed 70-millimeter film.

Throughout the 1950s, Paramount released many classic films that still impact audiences today. These include George Stevens's *A Place in the Sun*, starring Montgomery Clift and Elizabeth Taylor; *When Worlds Collide*, Paramount's entry into science-fiction; and several Bob Hope films that consistently proved popular. Cecil B. DeMille's only Best Picture winner, *The Greatest Show on Earth*, was released in 1952. *Roman Holiday*, starring Audrey Hepburn and Gregory Peck, earned Hepburn a Best Actress Oscar in her first Hollywood role. Alan Ladd appeared in the classic film *Shane*, which garnered Paramount six Academy Awards and millions at the box-office. Paramount also succeeded with George Pal's *War of the Worlds*; *Stalag 17*, starring William Holden; and with Grace Kelly's Oscar-winning performance in *The Country Girl*.

In this same period, Alfred Hitchcock successfully paired stars in his Paramount blockbusters, like James Stewart and Grace Kelly in *Rear Window*, Kelly and Cary Grant in *To Catch a Thief*, John Forsythe and Shirley MacLaine in *The Trouble with Harry*, and James Stewart and Doris Day in *The Man Who Knew Too Much*. Hitchcock closed out the decade by pairing James Stewart opposite Kim Novak in *Vertigo*.

In 1956, Cecil B. DeMille brought Paramount his last and biggest hit: *The Ten Commandments*, starring Charlton Heston. It more than tripled the receipts of Paramount's previous record setter.

During the early 1960s, Alfred Hitchcock produced *Psycho*—starring Janet Leigh and Anthony Perkins—which became one of Paramount's highest grossing films. Other releases during these years include Audrey Hepburn's *Breakfast at Tiffany's*; *Hud*, with Paul Newman; and several releases from Elvis Presley. During the mid-1960s, Paramount released *The Carpetbaggers*, *Fall of the Roman Empire*, *Love with the Proper Stranger*, John Wayne's *The Sons of Katie Elder*, and *The Spy Who Came in from the Cold*, starring Richard Burton and featuring a cast that included coauthor Marc Wanamaker's uncle Sam.

In October 1966, Paramount was purchased by Gulf + Western Industries, which was headed by Charles Bluhdorn. Bluhdorn wasn't through, though. A year later, G+W bought Desilu, which included the former RKO lot in Hollywood and adjoined the Paramount lot. Bluhdorn, along with Desilu owner Lucille Ball, ceremoniously merged the two Hollywood lots by cutting a ribbon made out of film stock.

After the merger, a massive remodeling campaign was launched to accommodate the arrival of the former Desilu television shows on the lot. The Paramount water tower that overlooked the center of the property was removed at this time, as the former RKO/Desilu tower was deemed sufficient to supply water for the entire property.

In 1967, former actor/producer Robert Evans brought *Barefoot in the Park*, starring Robert Redford, to the lot. That same year, Bluhdorn appointed Evans the head of production for the studio. Over the next seven years, Evans would bring Paramount some of the biggest hits in its history, including *The Odd Couple*; *Rosemary's Baby*; *Goodbye, Columbus*; *True Grit*; *Love Story*; *Plaza Suite*; *The Godfather*; *The Godfather Part II*; *Chinatown*; and *Harold and Maude*.

During the 1960s, Paramount was able to attract several famous directors, such as Nicholas Ray, Alfred Hitchcock, Michael Curtiz, John Ford, Howard Hawks, John Frankenheimer, Edward Dmytryk, Otto Preminger, Sydney Pollack, Roger Vadim, and Roman Polanski.

In 1970, Lew Wasserman, chairman of MCA/Universal, entered into a deal with Paramount on a combined distribution outlet for all regions of the world, except for the domestic market. Paramount, which now owned the former Desilu slate of television shows, was hosting several shows on the lot during this time, including *Mannix*, *Happy Days*, *Laverne & Shirley*, and *Taxi*.

In 1972, Paramount won its first Best Picture Academy Award in 20 years with *The Godfather*, which did huge business at the box office. Two years later, Paramount won another Best Picture Oscar for *The Godfather Part II*, which is considered by many to be the best sequel of all time. Other major Paramount releases of the 1970s include *Catch 22*, *On a Clear Day You Can See Forever*, *Marathon Man*, *Lady Sings the Blues*, *Day of the Locust*, *King Kong*, *The Shootist*, *The Bad News Bears*, *Serpico*, *The Last Tycoon*, *Saturday Night Fever*, *Grease*, and *Star Trek: The Motion Picture*.

The studio lot in the 1970s was ever changing, with new construction and the upgrading of existing facilities. "Virginia City," the Western set on the lot, was used by the *Bonanza* series at the time and became an icon in itself. Adjacent to Virginia City was a European street set used by such television shows as *Mission: Impossible*. In 1979, Virginia City was cleared to make way for a parking lot. The original Lasky-DeMille Barn, where *The Squaw Man*—one of the first full-length Westerns shot in Hollywood—was filmed in 1913, was moved off the lot and later became the Hollywood Heritage Museum. Paramount television shows in the 1980s included *Cheers*, *Family Ties*, *Entertainment Tonight*, and *Star Trek: The Next Generation*, which ran from 1987 to 1994.

Some of the more notable films of the 1980s made by the studio include *Urban Cowboy* with John Travolta, *Popeye* with Robin Williams, *Airplane!*, *Friday the 13th*, Robert Redford's *Ordinary*

People, Raiders of the Lost Ark, 48 Hours, An Officer and a Gentleman, Trading Places, Staying Alive, Flashdance, Terms of Endearment, Footloose, Witness, Ferris Bueller's Day Off, Crocodile Dundee, Children of a Lesser God, Beverly Hills Cop, and *The Untouchables.*

In 1988, Paramount purchased all the property on Melrose Avenue, between Van Ness Avenue and Windsor Avenue, and had it cleared (including the former Western Costume Company building) to make way for parking lots and new facilities. A new Paramount gate was built at Windsor Avenue at this time.

During the final decade of the 20th century, Paramount enjoyed several blockbusters and hit television shows; earned more Best Picture Oscars for *Forrest Gump, Braveheart,* and *Titanic;* and launched a new television network—the United Paramount Network (UPN). It also got a new owner when Sumner Redstone's Viacom completed a deal to purchase Paramount Communications in February 1994.

In addition to its Best Picture winners, Paramount released several successful films during the 1990s, such as *The Hunt for Red October, Days of Thunder, Ghost, The Godfather Part III, Another 48 Hours, The Naked Gun 2 ½, The Addams Family, Wayne's World, Patriot Games, What's Eating Gilbert Grape, The Firm, Congo, Clueless, The Brady Bunch Movie, Mission: Impossible,* and several more releases in the wildly successful *Star Trek* franchise. In 1997, the studio coproduced the biggest Hollywood hit of all time with *Titanic.* The 1990s ended with the release of successful and critically acclaimed films such as Steven Spielberg's *Saving Private Ryan* and *Star Trek: Resurrection.*

Paramount Pictures, born during Hollywood's turbulent founding era of the early 20th century, had survived two world wars, the Great Depression, the advent of sound and color, the loss of its theaters, the onslaught of television, the Cold War, and the birth of the Internet. As the 1990s drew to a close, Paramount, symbolized by its majestic mountain peak encircled by stars and tested by decades of triumphs and tribulations, entered the new millennium primed for another century of greatness.

One

1940–1949

PARAMOUNT THEATRE, 1939. In 1922, Sid Grauman hired William Woolett to design the largest movie theater of the time, on Sixth and Hill Streets, one block from Los Angeles's main theater district. The Paramount opened in January 1923, as Grauman's Metropolitan. Six years later, Grauman— who was most famous for his Chinese and Egyptian Theatres—sold the Metropolitan to Paramount. Paramount changed the name and used the venue for films and variety shows. The Paramount Theatre closed in 1960 and was demolished a year later.

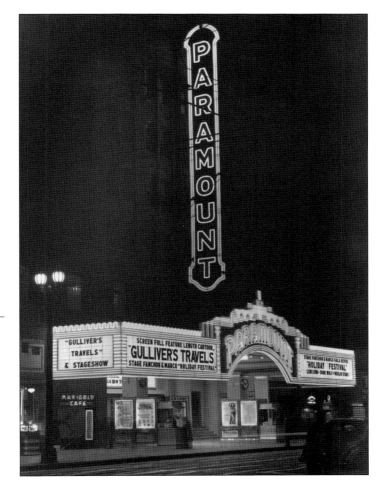

PARAMOUNT LOT STAGE 5 & 6, 1940. Actress Ellen Drew enters Stage 5. In the 1940s, productions like the Bob Hope/Bing Crosby film *Road to Rio* and the Montgomery Clift vehicle *The Heiress* were filmed on this stage.

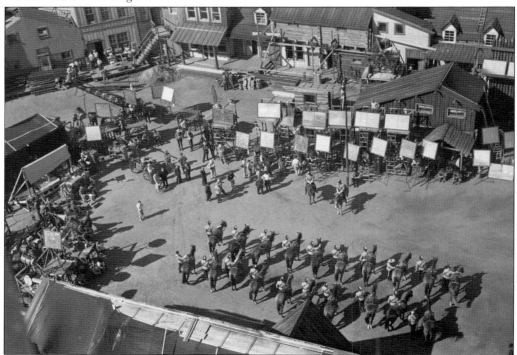

PARAMOUNT BACKLOT, 1940. Cecil B. DeMille is seen at the center of this photograph, directing the action of his first Technicolor film, *North West Mounted Police*. The movie would become Paramount's top grossing film of 1940, and Anne Bauchens would win an Academy Award for best film editing.

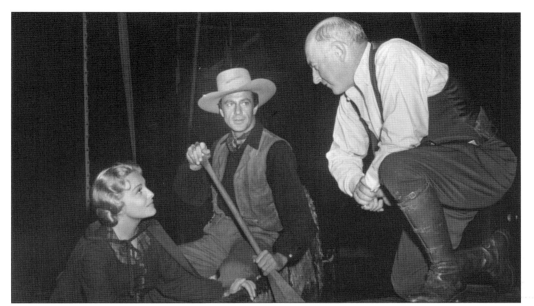

North West Mounted Police, 1940. Gary Cooper (center) and Madeleine Carroll listen as director Cecil B. DeMille instructs them on the set of the Academy Award–winning film *North West Mounted Police*. Originally, Joel McCrea was scheduled to star in this film, but when Cooper turned down the Hitchcock film *Foreign Correspondent*, the actors traded roles.

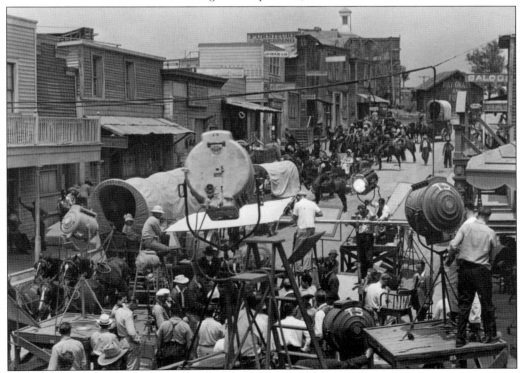

Cherokee Strip, 1940. The Western Town set seen here shows the production crew preparing a scene for Paramount's *Cherokee Strip*, starring Richard Dix.

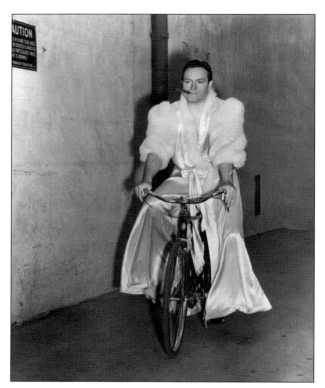

BOB HOPE, 1941. Bob Hope, pictured in drag on a break from filming *Nothing But the Truth*, began entertaining as a child for pocket change before eventually starting a vaudeville act. While performing in New York, he did a series of short films before obtaining a contract from Paramount. Hope worked tirelessly and achieved success in every field of show business. He also made an unprecedented 57 USO tours, entertaining American troops in foreign countries. He died at the age of 100, in Toluca Lake, California.

PRODUCTION PARK, 1942. Paulette Goddard started her career as an extra in Laurel and Hardy films before starring in *Modern Times* and *The Women*. Before arriving at Paramount in the 1940s—where she costarred with Bob Hope, Ray Milland, and Gary Cooper—she lost the role of Scarlett in *Gone with the Wind* to Vivien Leigh.

HOLIDAY INN, 1942. Bing Crosby costarred with Fred Astaire and Marjorie Reynolds, pictured here, in the Academy Award–winning film *Holiday Inn*. Irving Berlin wrote "White Christmas" for the film, which would win the Oscar and become the biggest selling song in history—selling over 150 million copies worldwide. The original 1942 masters were later damaged, and Bing rerecorded the song in 1947 to create the version that is sold today.

HAPPY GO LUCKY, 1943. Mary Martin—seen here being directed by Curtis Bernhardt (facing the camera)—started her career dubbing the voices of other stars. Martin graduated to a film career of her own, but she achieved her greatest success on the Broadway Stage—winning the Tony Award for her roles in *South Pacific*, *Peter Pan*, and *The Sound of Music*.

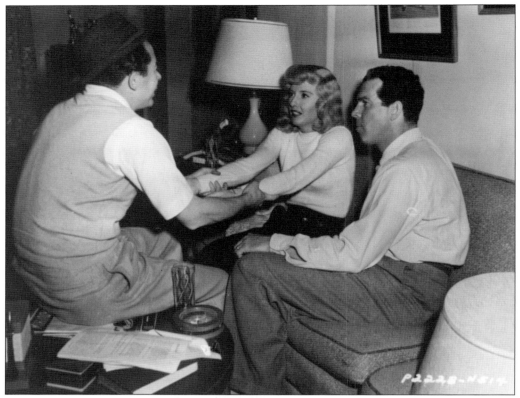

DOUBLE INDEMNITY, 1944. In 1942, Billy Wilder directed his first picture for Paramount: *The Major and a Minor*, which starred Ginger Rogers. Two years later, he would cowrite and direct the seven-time Academy Award–nominated blockbuster *Double Indemnity*. He is pictured above with the film's stars, Barbara Stanwyck and Fred MacMurray. The final production cost for the film was just over $900,000, and in its initial run at the box office, Paramount took in $2.5 million. *Double Indemnity* has stood the test of time and is regularly included in lists of the top 100 greatest films.

DIXIE, 1943. Bing Crosby starred with Dorothy Lamour in *Dixie*, directed by Eddie Sutherland. Pictured here, Crosby plays a 19th-century songwriter in New Orleans.

CHINA, 1943. Alan Ladd (left) and costar William Bendix are seen here on their way to the Paramount commissary during a lunch break. The five-foot-seven Ladd was one of Paramount's biggest stars for over 10 years and was often paired with the five-foot-one Veronica Lake, since their heights didn't conflict on screen. In 1952, after making the classic Western *Shane* (which was held for release until 1953), Ladd left Paramount, which he later claimed was a big mistake. In 1964, while suffering from insomnia, Ladd died after accidentally overdosing from a mixture of alcohol and three different sleep medications.

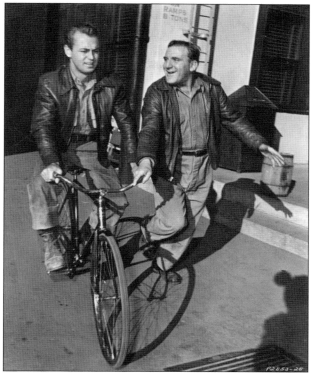

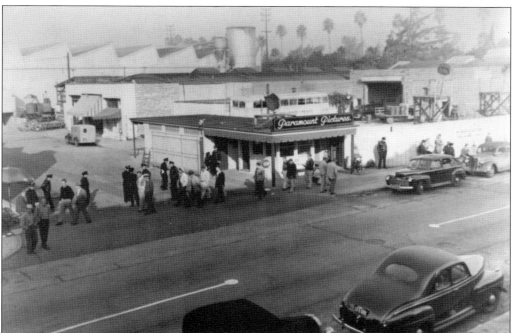

VAN NESS GATE, 1946. By the late 1930s, the Paramount lot had expanded incrementally to Van Ness Avenue with the addition of production facilities. A truck gate was opened, allowing access to Van Ness Avenue without impacting the main studio lot.

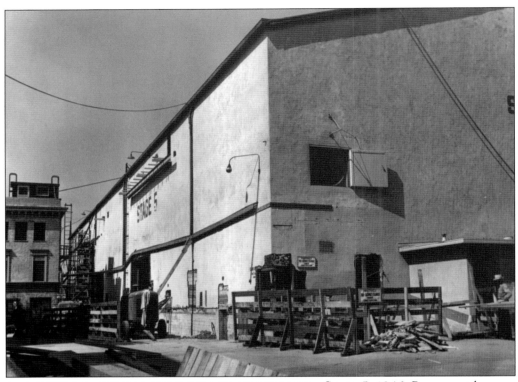

STAGE 5, 1946. Paramount began remodeling and modernizing the studio lot to accommodate the larger productions planned after World War II. Stage 5 was one of the older stages that needed new soundproofing, strengthening, and height adjustments. Stage 5 hosted such well-known films as Grace Kelly's *The Country Girl* and Hitchcock's *Vertigo*, as well as the television series *Monk*.

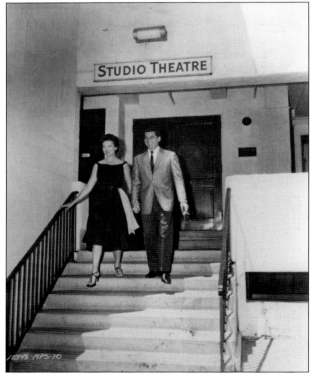

STUDIO THEATRE, 1948. The Paramount Studio Theatre is still located in the projection and editing section of the Paramount lot. In the past, the facility was used for viewing "rushes," the daily footage shot for various productions to see if re-shoots were needed.

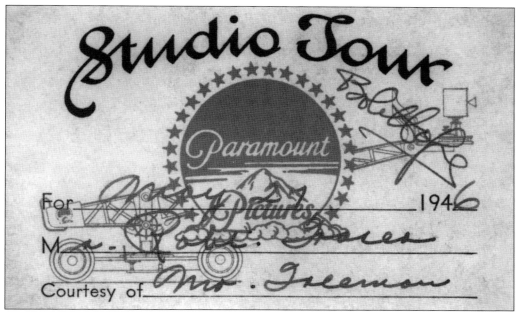

STUDIO TOUR, 1946. Paramount started a tour in the 1940s to give the family and friends of employees and VIPs a chance to see the inner workings of the studio. Today, Paramount offers a two-hour, a deluxe four-and-a-half hour, and a twilight version of the tour to the public. Depending on what tour you take, guests can see props, costumes, soundstages, backlots, and maybe even a star or two.

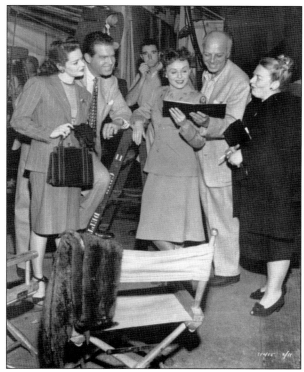

SUDDENLY IT'S SPRING, **1947.** In 1947, Paramount sued David O. Selznick's Vanguard Films because both companies were planning to release a film with the title *Suddenly It's Spring.* When the dust settled, Selznick's film, which starred Cary Grant, was retitled *The Bachelor and the Bobby Soxer.* Pictured on the set of Paramount's *Suddenly It's Spring* are, from left to right, Arlene Whelan, Fred MacMurray, Paulette Goddard, director Mitchell Leisen, and a visitor.

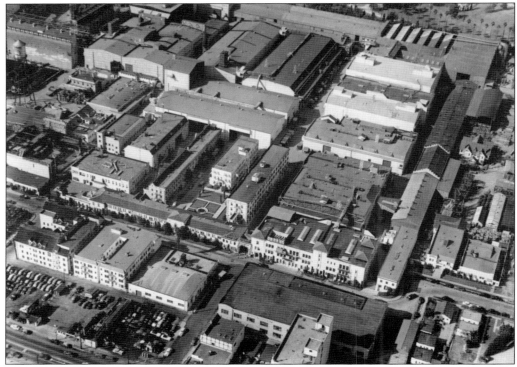

AERIAL VIEW OF PARAMOUNT STUDIOS, 1947. Looking north from Melrose Avenue, this photograph shows Marathon Street and the Bronson Gate at the center.

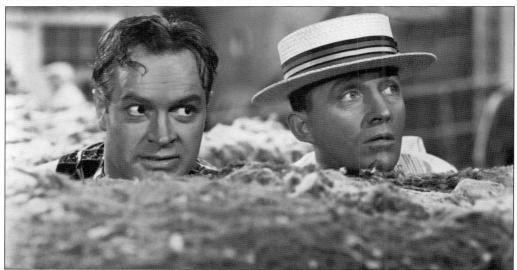

ROAD TO RIO, 1947. Bob Hope and Bing Crosby made seven *Road* films, with all but the final movie being released by Paramount. These popular films also starred Dorothy Lamour as a "straight man" for the boys. The films were highly popular, thanks to the zany comedy provided by Hope and Crosby, who frequently broke the fourth wall to speak directly to the audience. In *Road to Bali*, Hope turns to the camera and says, "Crosby's going to sing, folks. Now's a good time to go get some popcorn."

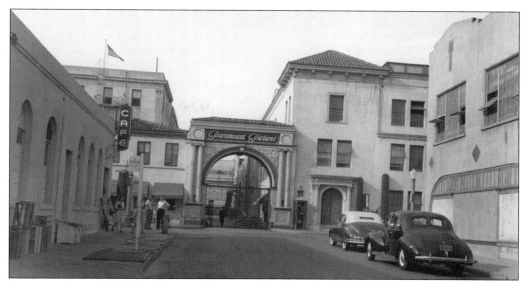

BRONSON GATE, 1947. The Bronson Gate served as the main entrance to the studio. The door to the right of the gate led to the casting office, and the floor above housed the wardrobe department and the offices of eight-time Academy Award–winning costume designer Edith Head. In 1948, the Academy actually created the Best Costume Designer award for her. Head clothed every Paramount production for 43 years before leaving for Universal.

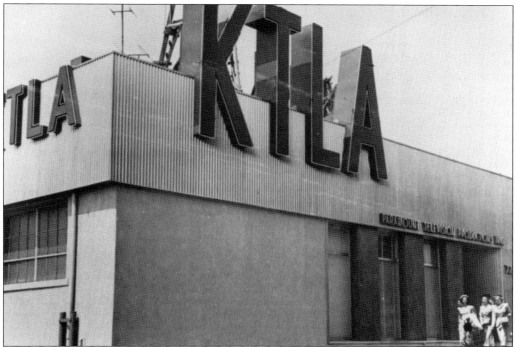

KTLA TELEVISION, 1947. KTLA's original television company began as W6XYZ Paramount Television in 1939. It was located at 721 North Bronson Avenue and Marathon Street, and was headed by Klaus Landsberg. KTLA moved to its present site, at Sunset Boulevard and Van Ness Avenue, in 1958.

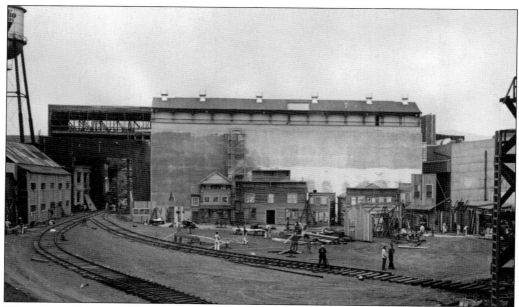

WHISPERING SMITH, 1948. The "B" Tank was set up here for *Whispering Smith*, which starred Alan Ladd and Brenda Marshall. Marshall was born Ardis Ankerson and hated her stage name so much that she insisted people call her Ardis. She went on to become the wife of Paramount star William Holden. During her career, she starred opposite such Hollywood heavyweights as John Garfield and James Cagney.

SAMSON AND DELILAH, 1949. DeMille filmed this scene at Paramount's "B" Tank, catching the RKO water tower in the background. The camera angle would cut the tower out of the final print. Victor Mature won the part, costarring with Hedy Lamarr, after Burt Lancaster turned it down. At the time of its release, *Samson* was the third biggest moneymaking film of all time.

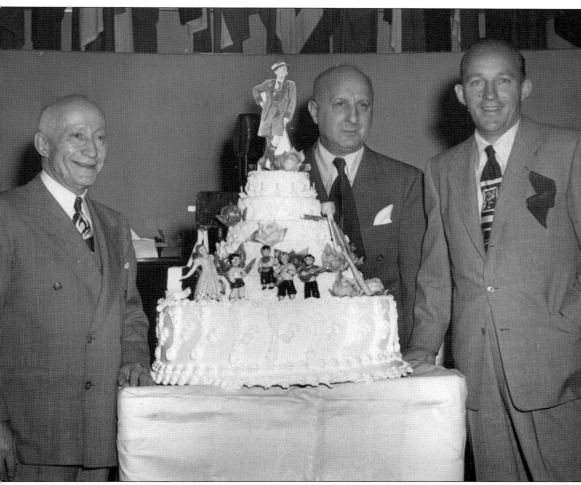

THE EMPEROR WALTZ, 1948. Paramount executives Adolph Zukor (left) and Barney Balaban (center) join the film's star, Bing Crosby, for some cake to celebrate the film's wrap. Balaban owned a successful movie theater chain and was the first to build a viewing balcony and add air conditioning to his theaters. Famous Players-Lasky bought an interest in the chain in 1926, and in July 1936, Paramount's board of directors elected Balaban president of the studio—a position he would hold until 1964.

PARAMOUNT FIRE DEPARTMENT, 1949. Adolph Zukor, Paramount's "Founding Father," remained active at the studio even after stepping down from day-to-day activities. Zukor is seen here at the fire department continuing a ritual he began in the 1920s—personally checking in on all of the studio departments to see how things were going.

Two

1950–1959

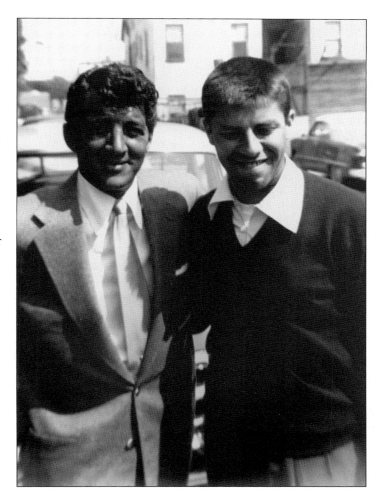

DEAN MARTIN AND JERRY LEWIS, 1950. Martin (left) and Lewis first teamed up in 1946 at the 500 Club in Atlantic City, New Jersey. Soon they were the biggest act in show business. When they moved into radio, producer Hal Wallis took notice and, in 1949, signed them to a five-year contract at Paramount that paid the duo $75,000 per movie and allowed them to make one film a year for their own company. Their first Paramount film was based on the radio series *My Friend Irma*. When they were signed, *Irma* was already in production, but Wallis ordered some quick rewrites to the script so Martin and Lewis could be inserted into the film.

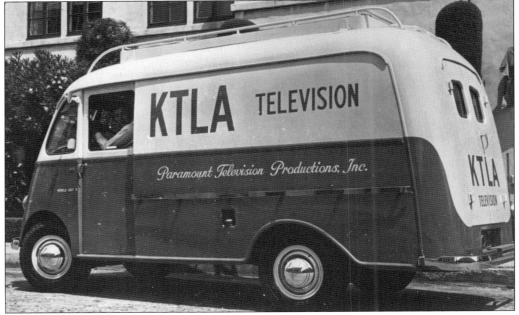

KTLA MOBILE UNIT, 1950. In 1949, KTLA became the first television company to use mobile television units to report on local news events in Los Angeles. In 1958, KTLA moved from its original studio, across the street from Paramount's Bronson Gate, to the newly acquired Paramount Sunset Studios at Sunset Boulevard and Van Ness Avenue. The site had been the home of the original Warner Bros. Hollywood Studios.

CAPTAIN CHINA, 1950. The rough waters of the South China Sea that washed John Payne's character off his ship were actually located right off of Bronson and Marathon Streets as Paramount's "B" Tank doubles for the Orient. Note the typewriter on the table signifying that on-set rewrites for the scene were underway.

ISOTTA FRASCHINI, *SUNSET BOULEVARD*, 1950. Erich Von Stroheim (right) and William Holden (left) are parked in front of the Writers Building (the Dreier Building), across from Stage 18. The Dreier Building looks virtually the same today. Isotta Fraschini was an Italian company that provided cars for many films.

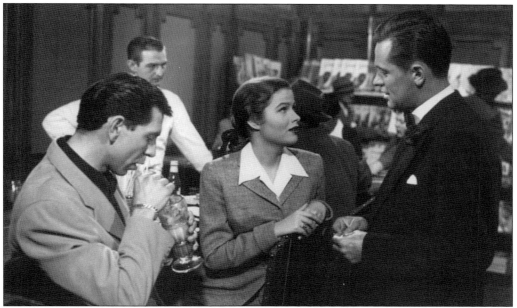

SUNSET BOULEVARD, 1950. Jack Webb, Nancy Olson, and William Holden (pictured from left to right) share a scene in the classic Hollywood film about an up-and-coming Hollywood writer and a down-and-out delusional star. Upon its release, *Sunset Boulevard* was a critical success, taking in $2.5 million at the box office. Nominated for 11 Academy Awards, it won three. In recent years, this Billy Wilder classic was honored by the United States Library of Congress, the National Film Registry, and the American Film Institute.

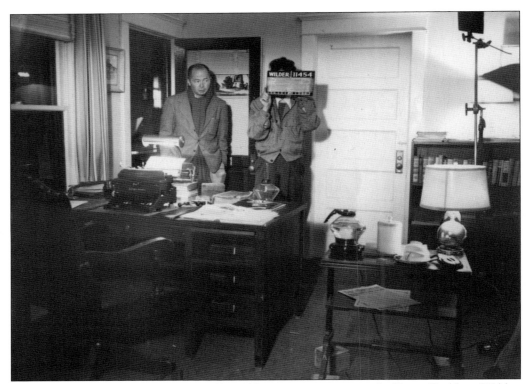

SUNSET BOULEVARD, 1950. Director Billy Wilder prepares a scene in the Dreier Building. Wilder, along with cowriter Charles Brackett, based the main character on several silent film stars, such as Mary Pickford and Clara Bow. Before settling on Gloria Swanson and William Holden as the leads, Wilder considered Norma Shearer and Greta Garbo for the role of Norma, and Fred MacMurray and Montgomery Clift for the role of Joe. At the time of its release, *Time* magazine described *Sunset Boulevard* as "Hollywood at its worst, being told by Hollywood at its best."

SUNSET BOULEVARD, 1950. "I made twenty pictures for Paramount and they want me to audition?" This was Gloria Swanson's reaction when asked to screen test for her role. While conferring with director George Cukor, he told her, "This is the part you're going to be remembered for; do it." Pictured here with Swanson (right) is costumer Edith Head.

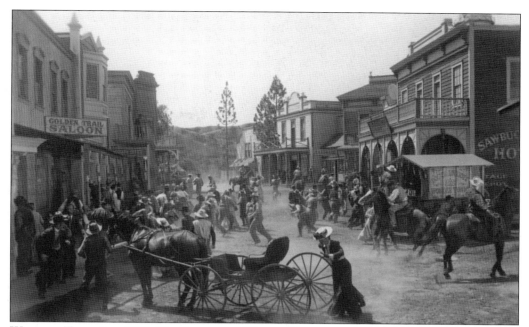

WESTERN TOWN SET, 1951. The Paramount Western Town set is dressed for *The Paleface*, starring Bob Hope and Jane Russell. Note the hills at the end of the street, which were actually made of wood and plaster and blocked out the RKO Art Department building that was adjacent to the town set.

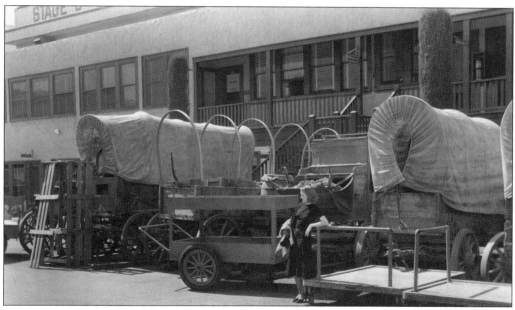

STAGE 8 AND THE PARAMOUNT ART DEPARTMENT, 1953. The second floor of the Stage 8 offices housed the Paramount Art Department, where drawings of production designs were created for the various films. The second floor was also home to the editing rooms for the Short Features and Trailer Departments. The stagecoaches parked in front of the Stage 8 and 9 building were being readied for use in the film *Pony Express*.

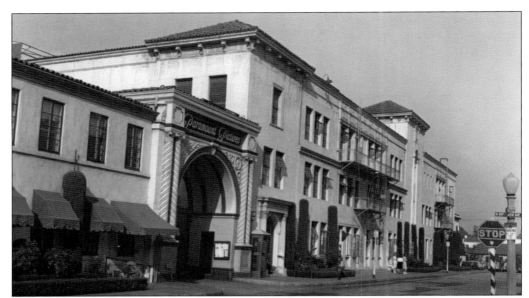

BRONSON GATE, 1950. Paramount's main entrance was at the intersection of Bronson Avenue and Marathon Street. The door to the immediate right of the Bronson Gate housed Paramount's Casting and Wardrobe departments. On most mornings, you could find a variety of people dressed in costumes hanging around this door looking for acting extra work. To the right, out of the photograph's view, were the Western Costume Company Building and Oblath's Studio Café.

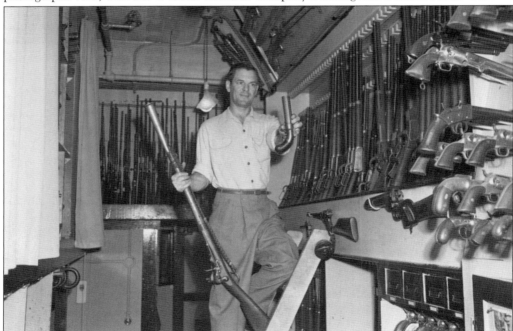

PARAMOUNT ARMORY, 1950. The Armory Department was headed by arms expert James E. Stembridge. He founded the armory on the studio lot, which was known to have some of the finest firearms in Hollywood. Other studios frequently rented Stembridge's rare and unusual firearms for their productions.

BRONSON GATE, 1950. The main entrance to Paramount Studios was put to good use in *My Friend Irma Goes West*, starring Dean Martin and Jerry Lewis. Here, an unusual and rare shot taken from above the gate shows director Hal Walker setting up a shot. Hollywood superstition says that if you touch the Bronson Gate it will bring you good luck.

MY FRIEND IRMA GOES WEST, 1950. Marie Wilson backs herself into a hole in Martin and Lewis's *Irma Goes West* while (from left to right) Martin, Diana Lynn, John Lund, and Corinne Calvet look on. *Irma Goes West*, released in July 1950, was the only sequel made by the comedy team. *At War with the Army* was filmed before it, but was held for release until January 1951—making *Irma Goes West* Martin and Lewis's second Paramount release.

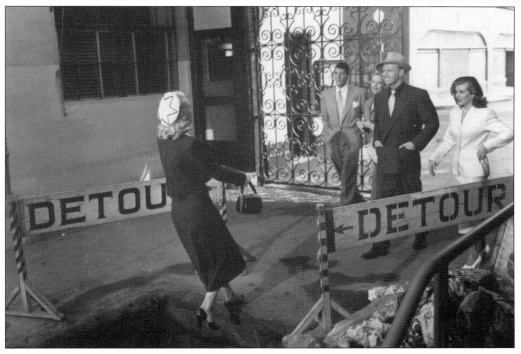

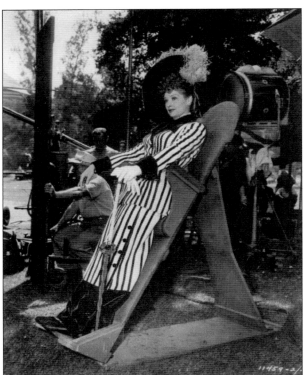

FANCY PANTS, 1950. Directed by George Marshall, Bob Hope stars with Lucille Ball in an amusing musical remake of *Ruggles of Red Gap*—with English valet Hope accompanying nouveau riche Lucille Ball to her new western home. Here, Lucy takes some time off on her "resting board," which kept her costume unwrinkled during filming respites.

A PLACE IN THE SUN, 1951. Elizabeth Taylor and Montgomery Clift starred in this George Stevens production for Paramount, which won six Oscars—including Best Director and Best Costume Design by Edith Head. Taylor and Clift would start a lifelong friendship after meeting on this film. Monty and "Bessie Mae," as he nicknamed Liz, would make two more films together before his untimely death at the age of 45.

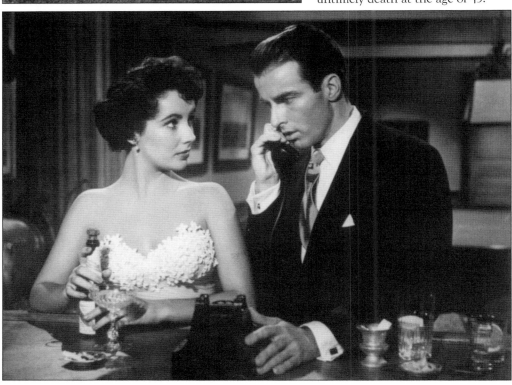

RKO Studio, 1952. In 1952, Marilyn Monroe appeared in *Clash by Night*, starring Barbara Stanwyck. Marilyn is seen here, walking through what is now "Lucy Park," which was previously known as both RKO Park and Desilu Park. Desilu was sold to Paramount Studios in 1967, merging the two adjacent lots into one.

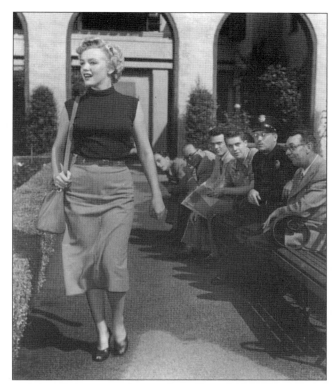

The Greatest Show on Earth, 1952. The only film made by director Cecil B. DeMille to win the Best Picture Oscar was *The Greatest Show on Earth*. This photograph of the trainwreck scene, which was created on a Paramount soundstage, captures the production's detailed set decoration.

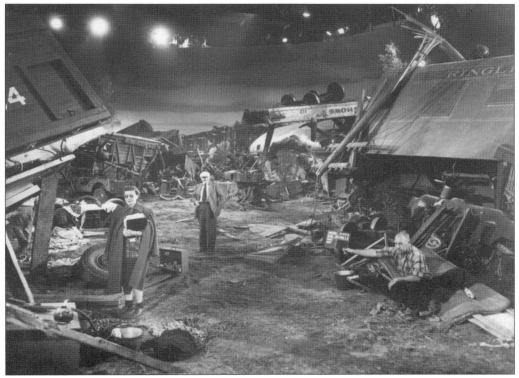

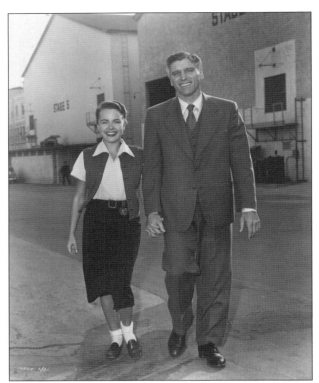

COME BACK, LITTLE SHEBA, 1952.
Burt Lancaster (right) and Terry
Moore, the stars of the film,
take a stroll around the studio
lot in-between scenes. Directed
by Daniel Mann, the film was
adapted from the William Inge
play and won costar Shirley Booth
an Oscar for Best Actress.

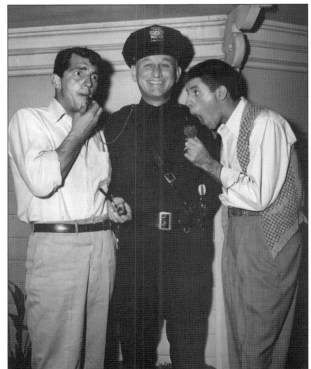

JUMPING JACKS, 1952. Dean Martin
and Jerry Lewis take a break to
tease Paramount police officer Otis
Homer Mathis. The Paramount
Police Department patrols the
studio lot 24 hours a day, protecting
the studio personnel and property.

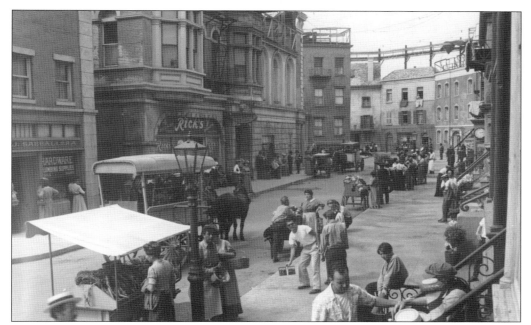

NEW YORK STREET, 1952. The outdoor set is seen here, dressed as a turn-of-the-20th-century Chicago street for the production of *Carrie*. This William Wyler film, about a poor farm girl who comes to the city and falls for an unhappily married restaurant manager, starred Jennifer Jones and Laurence Olivier.

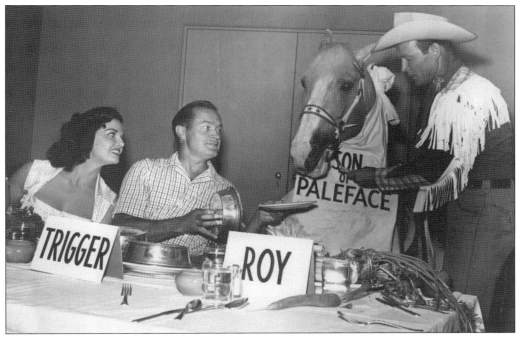

SON OF PALEFACE, 1952. Bob Hope and Jane Russell returned for the sequel to their successful film *Paleface*, this time with Roy Rogers and the smartest horse in the West: Trigger. Cecil B. DeMille, Bing Crosby, and the Beaver himself—Jerry Mathers—all appear in uncredited roles.

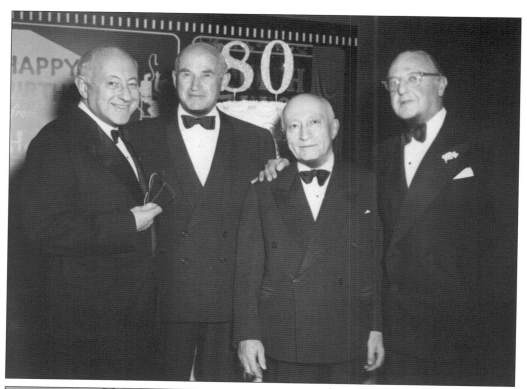

ADOLPH ZUKOR'S BIRTHDAY, 1953. Adolph Zukor's 80th birthday party was attended by his closest friends and former business partners from the formation of Paramount Pictures Corporation in 1916. From left to right are Cecil B. DeMille, Samuel Goldwyn, Zukor, and Jesse Lasky.

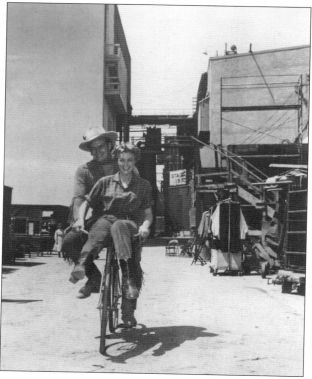

PONY EXPRESS, 1953. After completing a scene at the "B" Tank and sky backing for *Pony Express*, Charlton Heston gives costar Jan Sterling a ride back to their dressing rooms. The 1860s period film also made use of the Western town and other 19th-century American sets.

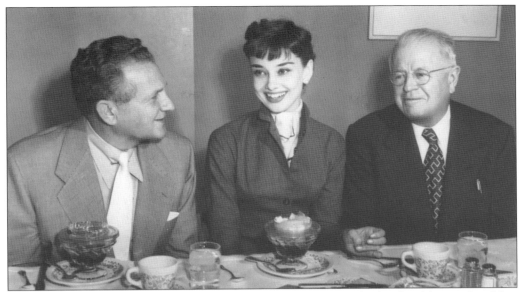

ROMAN HOLIDAY, 1953. New Paramount star Audrey Hepburn attends a lunch celebrating her debut film, *Roman Holiday*. Her hosts were production supervisor Don Hartman (left) and Paramount vice president Y. Frank Freeman (right). Gregory Peck's contract stated that only his name would appear above the title. However, when filming began and Peck saw Hepburn's performance he called his agents and demanded Audrey's name appear alongside his. Hepburn said it was the most generous thing any actor had done for a newcomer. Peck had great foresight—Hepburn took home a Best Actress Oscar for her part as Princess Ann.

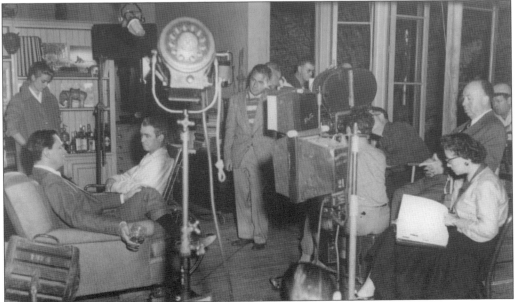

REAR WINDOW, 1954. This rare photograph shows the Stage 18 set of *Rear Window*, as Alfred Hitchcock prepares to direct a scene with Wendell Corey, James Stewart, and Grace Kelly. Hitchcock appears in a cameo role in nearly every one of his films, and *Rear Window* is no exception—when Stewart scans the goings-on of his neighbors, look for Hitch winding a clock.

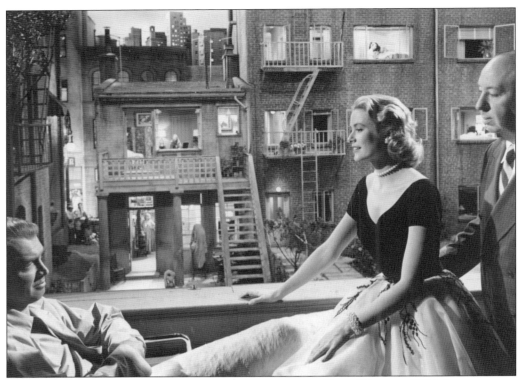

REAR WINDOW, 1954. James Stewart (left), Grace Kelly, and director Alfred Hitchcock discuss a scene on the set. Note the apartment house set in the background (through the window), where much of the action takes place in the film. The entire neighborhood that Stewart views in the film was constructed on Stage 18.

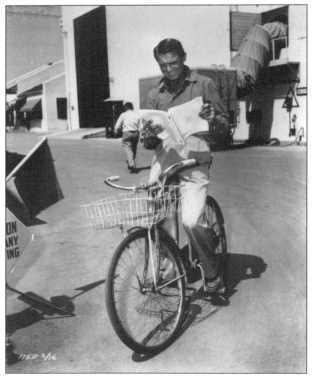

TO CATCH A THIEF, 1955. Cary Grant reads a script during a break in filming. Like many actors at the studio, Grant often made his way around the lot by bicycle.

To Catch a Thief, 1955.
Director Alfred Hitchcock coaches Grace Kelly, who appears in the famous gold lame gown that she wears in the costume ball scene. Designed by Edith Head, the gown was the most spectacular costume worn in the film.

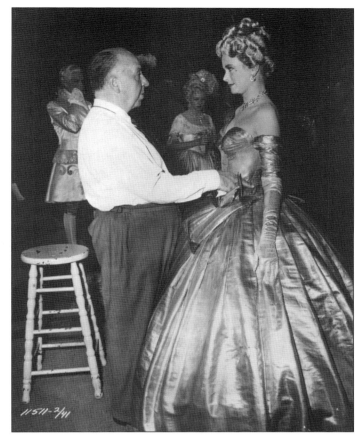

New York Street, 1955.
The New York Street backlot could be re-dressed to look like almost any city in the United States. Notice the cable grid above, which was used when the street needed covering to control lighting. Sprinklers were often used to spray water over the street to simulate rain effects.

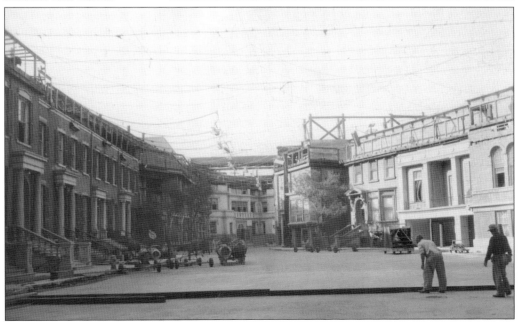

PARAMOUNT BACKLOT, 1955. This view looks southwest, at the property line of both the RKO Studios (at right) and the backlot where the new Western Town set is under construction. Note the wood and plaster miniature mountain—complete with oil wells. This mountain was needed to block off the view of RKO from the new set. The new Western Town became known as "Virginia City" and was used for the television series *Bonanza*.

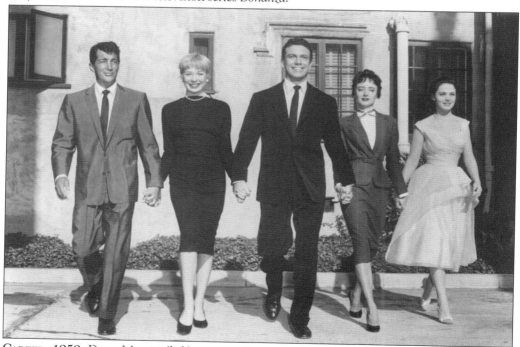

CAREER, 1959. Dean Martin (left) stars in *Career*, a story about Broadway actors, along with (from left to right) Shirley MacLaine, Anthony Franciosa, Carolyn Jones, and Joan Blackman. The quintet poses together behind the dressing room building—adjacent to the Administration Building. It was a common practice for Paramount's publicity department to have the studio's stars pose for photographs on the lot.

PARAMOUNT HOLLYWOOD THEATRE, 1956. The premiere of Alfred Hitchcock's *The Man Who Knew Too Much* was held at the Paramount Theatre, which was originally the El Capitan Theatre, on Hollywood Boulevard. The venue became the Paramount Theatre in 1942, when it premiered Cecil B. DeMille's *Reap the Wild Wind*.

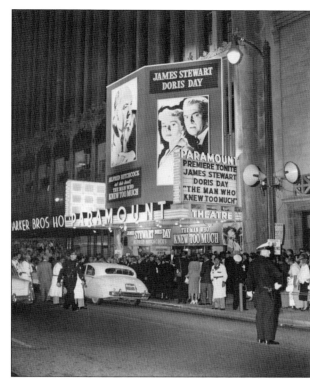

PARAMOUNT CAFÉ CONTINENTAL, 1957. The studio commissary was updated in 1942 and renamed the Café Continental. The commissary was traditionally where the stars, executives, and studio personnel met for lunch.

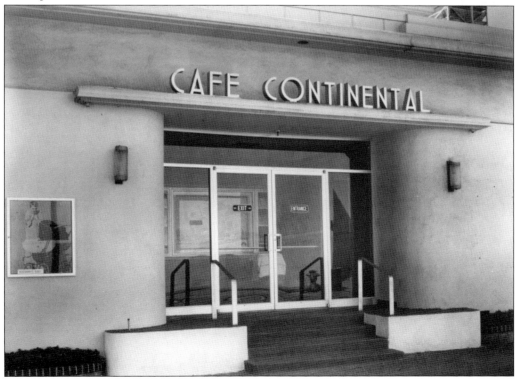

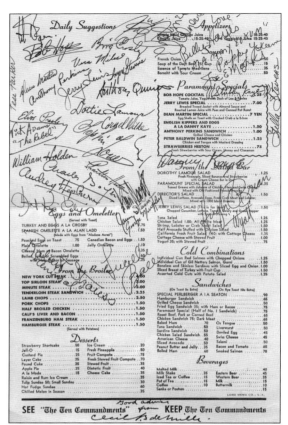

Paramount Café Continental, 1957. A commissary menu is seen here, signed by almost every star who was working on the studio lot at that time. It also advertises *The Ten Commandments*, and was signed by the film's director, Cecil B. DeMille. The Paramount Specials section had some fun with some of the studio's stars, like avid golfer Dean Martin. Diners ordering a "Dean Martin" off the menu received "egg shells on toast with cracked crab a la 5 iron."

DeMille Gate on Marathon Street, 1956. When Cecil B. DeMille returned to Paramount in 1932 after a seven-year absence, he requested he have his own building and auto entrance. Paramount accommodated him with the building that was located directly next to their main administration offices on Marathon Street. The auto gate was installed between two of the buildings.

PARAMOUNT "B" TANK AND SKY BACKING, 1956. Cecil B. DeMille is seen here directing the special water effects scenes for *The Ten Commandments* on the backlot. Note the Lasky-DeMille Barn in the background, where DeMille produced his first film, *The Squaw Man*, in 1914. The barn was originally located at Selma Avenue and Vine Street in Hollywood and was moved when the Paramount lot was purchased in 1926. At that time it became the studio's gym and meeting hall.

LASKY-DEMILLE BARN, 1956. Adolph Zukor is seen here walking next to the Lasky-DeMille Barn, which later became a California State Historical Monument. Zukor joined his friends and former business partners, Cecil B. DeMille, Samuel Goldwyn, and Jesse Lasky at the dedication ceremonies. The barn became a part of the new Western Street and was a setting in many Westerns over the years.

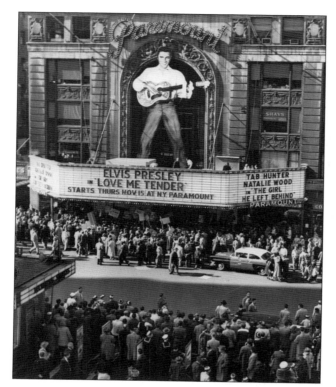

PARAMOUNT THEATRE NEW YORK CITY, 1956. Elvis Presley made a personal appearance on a stage erected on the giant marquee of the Paramount Theatre, heralding the opening of *Love Me Tender*. The Paramount Theatre, in the Paramount Building in Times Square, New York, was one of the grandest movie palaces ever built. Atop the building was a revolving stained-glass light beacon that was visible for miles.

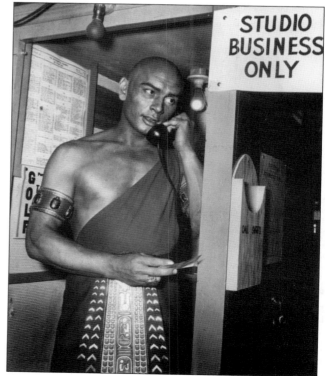

THE TEN COMMANDMENTS, 1956. Yul Brynner, who starred as Ramses, Pharaoh of Egypt, takes a few minutes off from shooting to make a telephone call from one of the telephone booths near the stage.

44

THE JOKER IS WILD, 1956.
Frank Sinatra pauses for photographs taken by continuity personnel to insure that he wears the same costume and accessories as in previous scenes. Sinatra plays the famous nightclub performer Joe E. Lewis in the film, which won an Oscar for the song "All the Way." Lewis, always quick with a quip, told Sinatra, "You had more fun playing my life than I had living it."

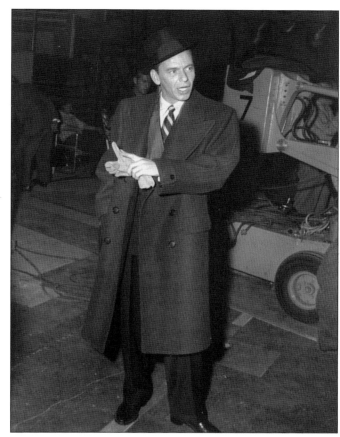

PARAMOUNT WESTERN STREET, 1956. The new Western Street—later known as the "Virginia City" Western Town set—was used by the NBC series *Bonanza*. The mountain set at the end of the street was made of wood and plaster and masked the RKO Art Department building on the opposite side.

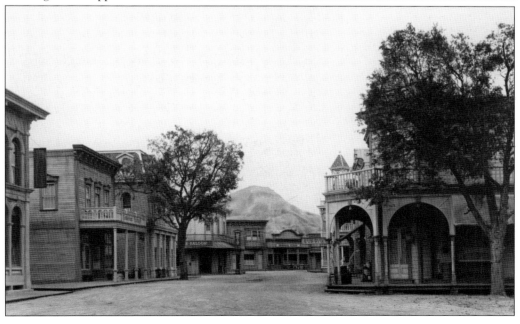

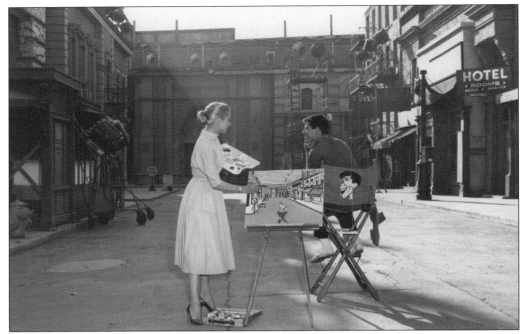

PARAMOUNT NEW YORK STREET, 1957. Actress Martha Hyer paints Jerry Lewis on the New York Street set used for Lewis's film *The Delicate Delinquent*. This film was Lewis's first solo starring role after his split with Dean Martin. Darren McGavin played the part originally intended for Martin.

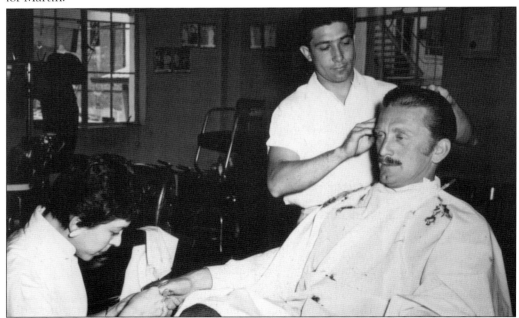

PARAMOUNT BARBER SHOP. 1957. Kirk Douglas has his hair and nails trimmed for scenes in *Gunfight at the O.K. Corral*. He costarred with Burt Lancaster in the story about the famous gunfight in Tombstone, Arizona. The Paramount Barber Shop is still open for business, next to Stage 2.

Desilu Studio Gower Street Entrance, 1957. Lucille Ball began her career in the 1930s as an RKO contract player. The success of her *I Love Lucy* television series allowed her, along with husband Desi Arnaz, to purchase RKO in 1957, renaming it Desilu Studios. Desilu was located on the lot adjacent to Paramount and was where *The Lucy Show* was filmed from 1962 to 1968, on what is now Stage 25. Paramount purchased Desilu and all its assets in 1967 and merged the two studio lots. Ball and Arnaz are seen exiting the Desilu Studios main entrance on Gower Street.

Production Park, 1957. This green park sat between the Dressing Room Building, Production Building, Directors Building, and Administration Building. The park was installed in 1926, when Paramount bought the studio. It was paved over in 1956 to make room for a parking lot, and it wasn't until the mid-1980s that the former park was reinstalled and renamed Production Park.

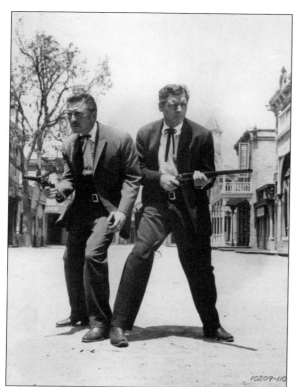

GUNFIGHT AT THE O.K. CORRAL, 1957. Kirk Douglas (left) and Burt Lancaster costar as Doc Holliday and Wyatt Earp in a gunfight scene on the Western Town set. Much of the outdoor action for the film was shot at several locations away from the studio like the Paramount Ranch Western Town in Agoura, California, and Old Tucson Studios in Arizona.

CAFÉ CONTINENTAL, 1957. In 1957, Cecil B. DeMille hosted a luncheon in the studio commissary, celebrating the recent release of *The Ten Commandments.* Mary Pickford and Samuel Goldwyn were in attendance. Other notables in the room that day included Anthony Quinn, Cornel Wilde, and Danny Kaye, along with Paramount directors, producers, and studio personnel. The event was broadcast on CBS Radio.

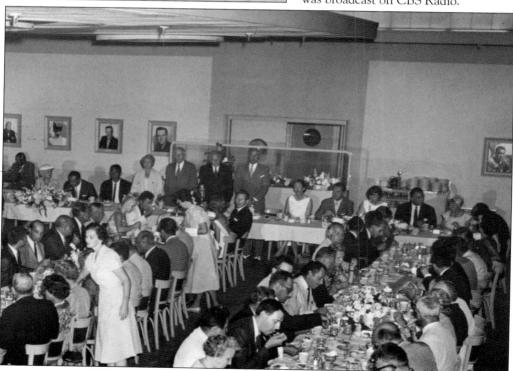

BRUNTON-UNITED STAGE 8 & 9 BUILDING, 1958. This building was constructed in 1919 by the Brunton Studios, which was acquired by United Studios in 1924. Two years later, Paramount purchased the entire United Studios lot, and the Brunton Building continued to house production offices, the art department, and dressing rooms. Recent Paramount personnel remember the building as the headquarters for the *Star Trek* series of films and television shows.

LASKY-DeMILLE BARN/STUDIO GYM, 1958. Yul Brynner starred with Charlton Heston in *The Buccaneer*, which depicts the battle of New Orleans in 1815. Anthony Quinn directed, and Cecil B. DeMille produced the film. At the time, the barn was used as a rehearsal hall, gymnasium, and meeting hall. Here, Brynner rehearses his sword fight scenes—in full costume—with the studio fencing instructor.

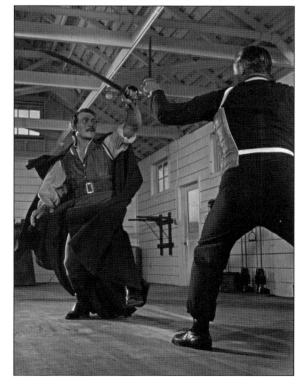

49

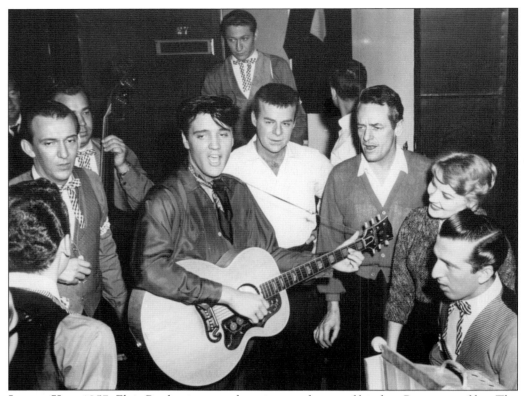

LOVING YOU, 1957. Elvis Presley is seen rehearsing on the set of his first Paramount film. The loosely autobiographical *Loving You* was in production on the Paramount lot from January to March 1957 and premiered in July that same year. A box office smash, in its initial run *Loving You* took in $3.7 million. The big song from the film was "(Let Me Be Your) Teddy Bear" with the flip side "Loving You," which sold over a million copies. Elvis's parents appear as extras in the last scene—the only time they appeared in one of his films.

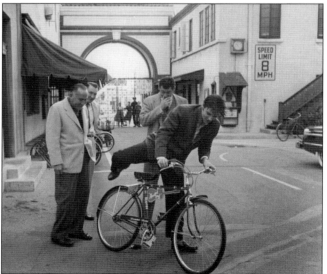

KING CREOLE, 1958. Producer Hal Wallis and associate Paul Nathan present a bicycle to *King Creole* star Elvis Presley. Wallis had the bicycle named "Hound Dog" after Elvis's hit song, which has sold over 10 million copies worldwide. *King Creole* was widely considered the best of Elvis's movies; it was also his favorite role and proved he had great acting ability. Twelve days after the completion of this film, Elvis was drafted into the US Army for a two-year stint during which he reached the rank of sergeant.

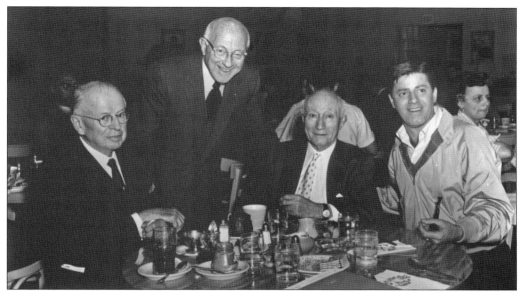

CAFÉ CONTINENTAL STUDIO COMMISSARY, 1958. Paramount chief Y. Frank Freeman (left), director Cecil B. DeMille (standing), and chairman emeritus Adolph Zukor dine with star Jerry Lewis in the studio's commissary.

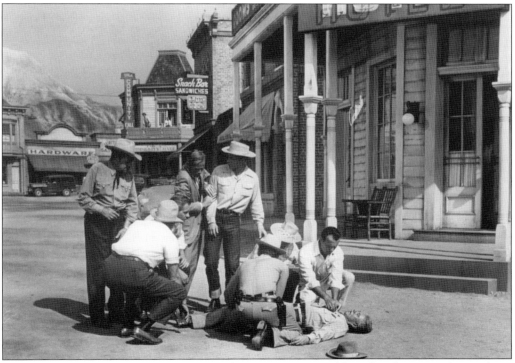

PARAMOUNT WESTERN TOWN SET, 1958. The town set was used here for *The Trap*, a drama about a small southwest desert town besieged by big city gangsters on the lam. Directed by Norman Panama and starring Richard Widmark and Lee J. Cobb, the film was one of many small dramas produced by Paramount at the end of the 1950s.

THE CECIL B. DEMILLE OFFICES, 1958. While directing *The Ten Commandments* (1956), Cecil B. DeMille suffered a series of heart attacks. He forced himself to complete the film, but his health had diminished so much that he asked his son-in-law actor Anthony Quinn to direct his next film, *The Buccaneer*. With his health in severe decline, DeMille started working from home more often, and his offices at Paramount were put to use by other producers and directors. On January 21, 1959, DeMille passed away at his home in Hollywood.

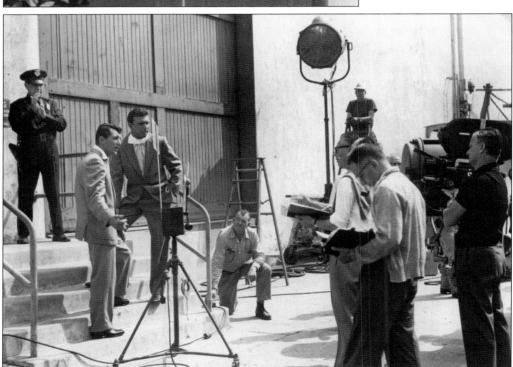

CAREER, 1959. Dean Martin and Anthony Franciosa are assisted with their lines by the dialogue coach, while director Joseph Stanley stands by. The film follows Franciosa's character—an actor facing ups and downs while seeking Broadway fame.

Three

1960–1969

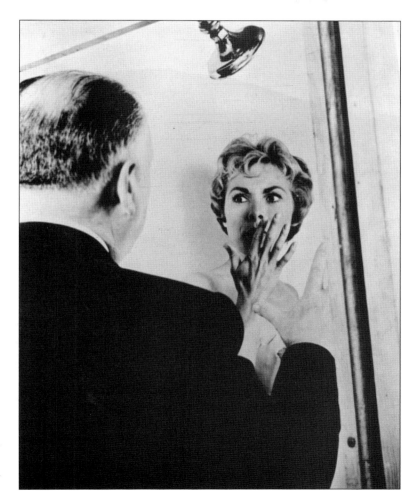

PSYCHO, 1960.
Alfred Hitchcock
directs Janet Leigh
in the famous
shower scene from
what many consider
Hitchcock's greatest
film. As a publicity
stunt upon its
release, a cardboard
cutout of Hitch
looking at his watch
was sent to every
theater with a sign
stating that no one
could be admitted
after the movie
started. The film
was a huge success,
with moviegoers
waiting in long lines
to see it. It was also
Hitchcock's last film
for Paramount.

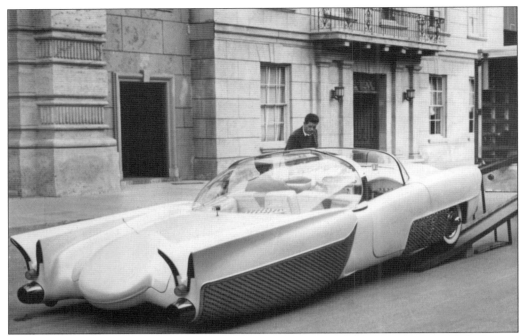

CINDERFELLA, 1960. The George Barris customized Lincoln Mercury automobile arrives on the Paramount lot for use by Jerry Lewis in *Cinderfella*, a comedic version of the famed Cinderella fairy tale.

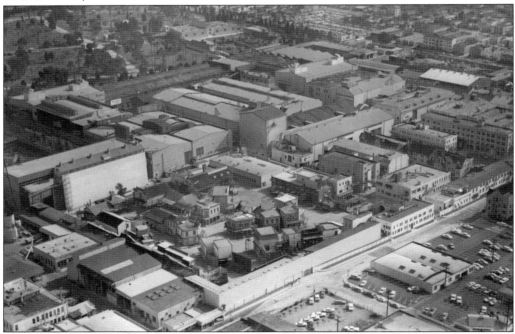

PARAMOUNT STUDIO LOT, 1960. Looking northeast from Marathon Street, this photograph shows the "B" Tank and Western Town, with the Lasky DeMille barn in the center. The Desilu Studios Art Department buildings are visible at the bottom left.

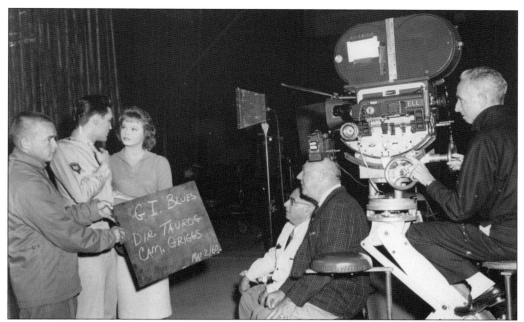

G.I. BLUES, 1960. Upon being honorably discharged from the US Army in March 1960, Elvis Presley starred in *G.I. Blues*, his first film in two years. Seen here with Juliet Prowse, Elvis started filming on the Paramount lot that May. Directed by Norman Taurog and photographed by Loyal Griggs—both pictured here on the set—Elvis sings one of his most famous songs, "Blue Suede Shoes," in the film. As expected, the film was a huge success—grossing over $4 million at the box office—and the soundtrack was nominated for two Grammy awards.

PARAMOUNT LOT, 1961. This view south, toward the Administration Building, shows the rear of the star dressing room building at left.

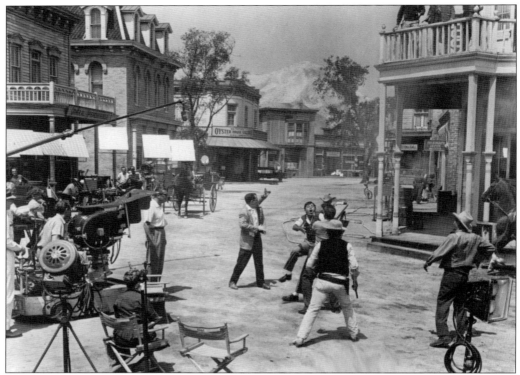

THE ERRAND BOY, 1961. Written by, directed by, and starring Jerry Lewis, *The Errand Boy* sees Lewis working at the fictional Paramutual Studios. Lewis's long string of gags provides the laughter as the action takes place all over the Paramount studio lot, with scenes showing the Western Town, shops, offices, and stages. Lewis is pictured disrupting a film in production on the Western Town set.

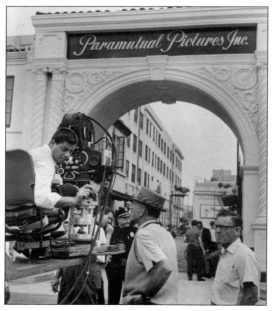

THE ERRAND BOY, 1961. Paramount's Bronson Gate is used as a location background in this photograph showing director and star Jerry Lewis behind the camera. The Paramount Pictures sign over the gate was changed to the fictional film studio "Paramutual Pictures." Jerry Lewis wrote, directed, and starred as the clumsy Morty S. Tashman, who gets a job as a movie studio errand boy. A highlight in the film is Lewis's very funny boardroom pantomime to Count Basie's "Blues in Hoss' Flat."

PARAMOUNT CAFÉ CONTINENTAL, 1961. Paramount studio executive Jack Karp (left) presents founding father Adolph Zukor with a photograph at Zukor's 88th birthday party on the lot, while one of Paramount's biggest stars, Jerry Lewis, looks on. In 1959, Jerry Lewis Productions entered into a contract with Paramount stating Lewis would receive $10 million and 60 percent of the profits for delivering 14 films in seven years.

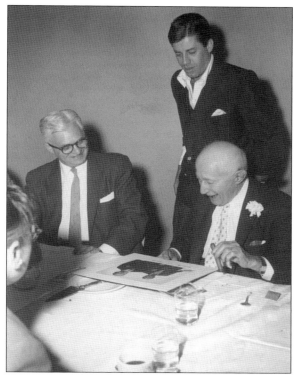

BREAKFAST AT TIFFANY'S, **1961.** Audrey Hepburn and George Peppard star in this adaptation of Truman Capote's novel, with Hepburn as "Holly Golightly." Henry Mancini cowrote the Academy Award–winning theme song, "Moon River," with Johnny Mercer. Here, a stage hand in a raincoat holds "Cat," as he was named in the film, while everyone looks to director Blake Edwards (not pictured) to see if he wants another take.

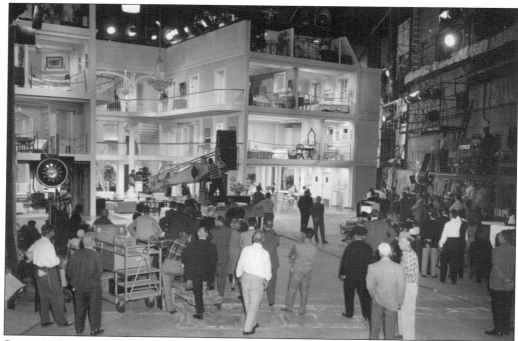

STAGE 18 PARAMOUNT LOT, 1961. Jerry Lewis once again starred in, wrote, and directed another Paramount comedy: *The Ladies Man*. In the film, Herbert T. Heebert is jilted by his girlfriend and lands a job as a handyman in an all-girls boardinghouse. Stage 18 was for a time nicknamed "*The Ladies Man* Stage" due to its enormous set that many reviewers claimed was the real star of the film.

PARAMOUNT BACKLOT, 1961. Here, adjacent to the New York Street set, is the newly added "Modern Storefronts" exterior set. These modern settings were used for more contemporary films of the time. Paramount, like most Hollywood Studios, built them to avoid the logistical problems and expense of filming on location.

PRODUCTION PARK, 1962. The former "Production Park" behind the Administration Building on Marathon Street became a parking lot, servicing the Star Dressing Room Building on the left, the Production Building in the center, and the Directors Building (not pictured) on the right.

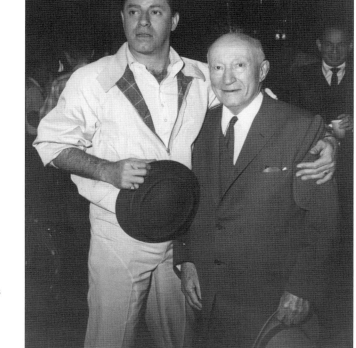

ADOLPH ZUKOR, 1962. Even 50 years after founding the company, Adolph Zukor still kept an eye on things. Here, he visits Jerry Lewis on the set of *It's Only Money.* Lewis's contract with Paramount stated after 10 years of the release date he would receive all the rights to his films.

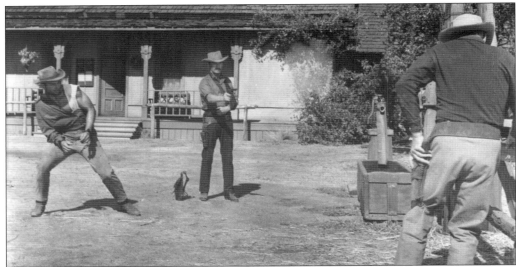

STAGE TO THUNDER ROCK, 1963. The Lasky-DeMille barn serves as a backdrop in this A.C. Lyles film. Lyles produced many Westerns throughout the 1960s, with stars who weren't getting work in "A" films. *Thunder Rock* was no exception, featuring the familiar faces of Barry Sullivan, Marilyn Maxwell, and Keenan Wynn in the cast. Morgan Brittany, who later appeared on the television show *Dallas*, plays a young girl in this film.

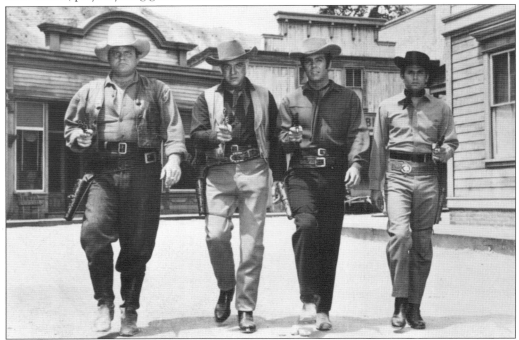

PARAMOUNT "VIRGINIA CITY" WESTERN TOWN, 1963. The first 11 seasons of *Bonanza*'s 14 year run were filmed at Paramount. When Ben Cartwright and his sons, Adam, Hoss, and Little Joe, rode into Virginia City they were really only a block or so off of Bronson and Marathon Streets. *Bonanza* was one of the most watched series in television history, holding the record for consecutively remaining in the top five most watched shows for nine straight years.

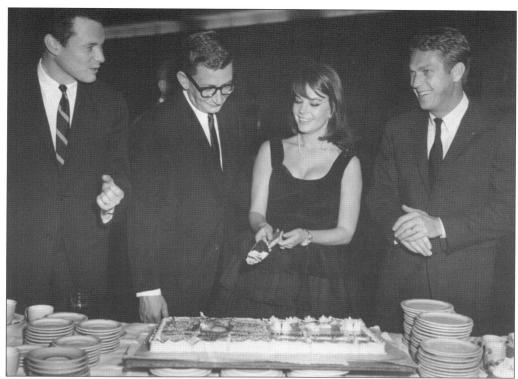

LOVE WITH THE PROPER STRANGER,
1963. From left to right, Alan J. Pakula, Robert Mulligan, Natalie Wood, and Steve McQueen attend a commencement party announcing the five-time Academy Award–nominated film. Dealing with the controversial subjects of one night stands and abortion, the film was arguably the most dramatic roles that Wood or McQueen would ever play. Tom Bosley, making his film debut, would return to the lot in 1974 for a 10-year run on the television series *Happy Days.*

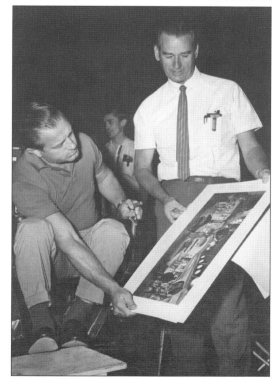

CARPETBAGGERS, **1964.** Director Edward Dymtryk, seen here inspecting some artwork, refused to testify before the House Un-American Activities Committee (HUAC) during their 1947 investigation into suspected communism in the film business. Named one of the "Hollywood Ten," he served time in prison for contempt of court and was blacklisted from working. He eventually repented and went on to make such classic movies as *The Caine Mutiny* and *The Young Lions.*

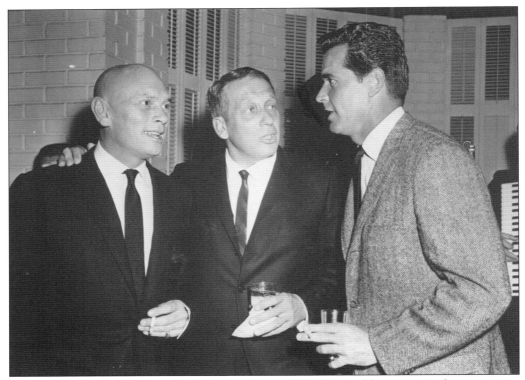

HOWARD KOCH, PARAMOUNT PRODUCTION HEAD, 1964. Pictured here at an industry party at Paramount, Howard Koch (center) discusses business with Paramount star Yul Brynner (left) and James Garner (right). Garner would later appear in the Paramount films *The Fan* (1981) and *Twilight* (1998).

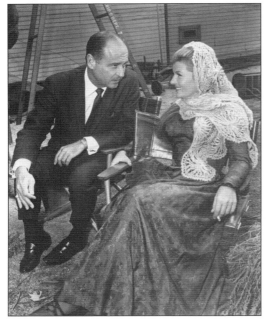

A.C. LYLES IN "B" TANK, 1965. Producer A.C. Lyles speaks to Corinne Calvet on the set of *Apache Uprising.* When A.C. was 10, he started working for the Paramount Theatre in Jacksonville, Florida. When Adolph Zukor visited the theater, A.C. expressed his desire to work in Hollywood. Zukor told him to keep in touch, and A.C. wrote him every week to no response. After graduating from high school, he showed up at the Bronson Gate looking for a job, which he would get in the mailroom. In his long tenure with Paramount, Lyles held a variety of positions and eventually became a film and television producer. When he passed away in 2013 at the age of 95, he was still employed at Paramount Pictures.

NEW YORK STREET, 1965. This photograph looks east toward the theater facade that abuts Stage 15. In 1987, the facade was changed into a Bronx, New York, high school entrance for the television show *The Bronx Zoo*.

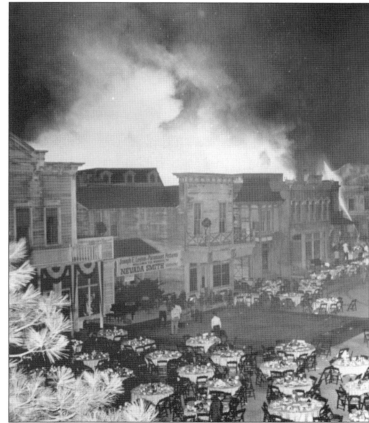

PARAMOUNT FIRE, 1965. During the wrap party for the film *Nevada Smith* (1966), starring Steve McQueen, set storage sheds ignited and created a major backlot fire that forced the guests to evacuate from the lot's Western Town sets.

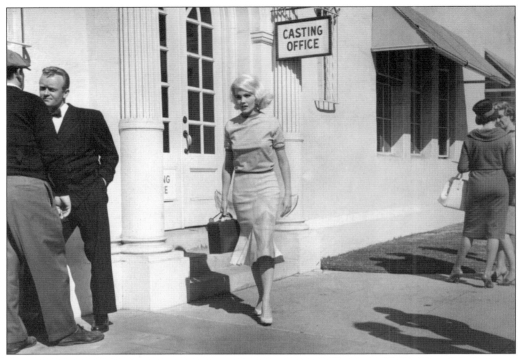

***HARLOW*, 1965.** Carroll Baker, portraying Jean Harlow, leaves the Paramount casting office, which was located outside the Bronson Gate. Paramount Studios was used as a location throughout much of the film. *Harlow* was one of three films that Baker did for Paramount, capitalizing on her sex-symbol persona.

***THAT GIRL*, 1966.** Marlo Thomas grew up around show business, watching her famous father, Danny Thomas, reach success on screen, stage, and television. After her parents insisted she have something to fall back on, Thomas graduated from college with a teaching degree before beginning her career as an actress. In a few short years, she would produce and star in her own show. *That Girl*'s "Ann Marie" was the first single girl to ever live alone on television. The exteriors for this episode, "The Defiant One," were filmed on New York Street.

MISSION IMPOSSIBLE, 1966. This former Desilu television series was shot on the Paramount lot from 1966 to 1973. *Mission Impossible* was one of the hit shows that Paramount acquired with the purchase of the Desilu Gower Studios. Featuring an all-star cast, the Emmy and Golden Globe–winning show ran for seven years and was later revived by Paramount as a successful movie franchise.

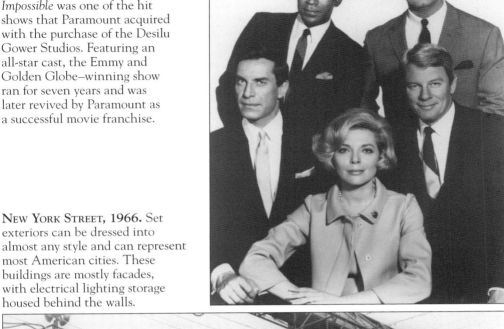

NEW YORK STREET, 1966. Set exteriors can be dressed into almost any style and can represent most American cities. These buildings are mostly facades, with electrical lighting storage housed behind the walls.

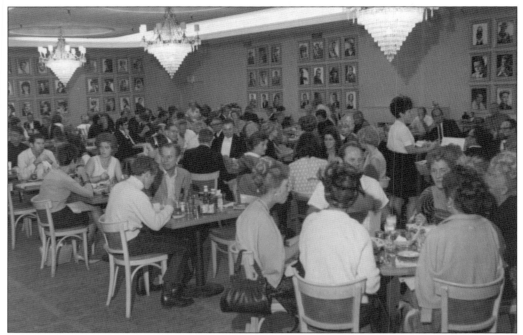

CAFÉ CONTINENTAL, 1967. This photograph shows the newly remodeled commissary, with stars, executives, and studio personnel at lunch. Nearly all of the studios—both major and minor—provided commissaries for their employees and stars.

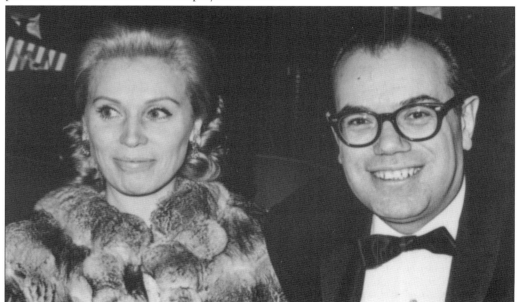

GULF + WESTERN, 1967. Charles and Yvette Bluhdorn are seen here at a film premiere. Bluhdorn was born in Austria and, at the age of 16, came to America for schooling. He opened his own auto parts business in his early 20s, which would make him a millionaire by the time he turned 30. That business would become Gulf + Western, which acquired Paramount Pictures in 1966, with Bluhdorn serving as chairman of the board.

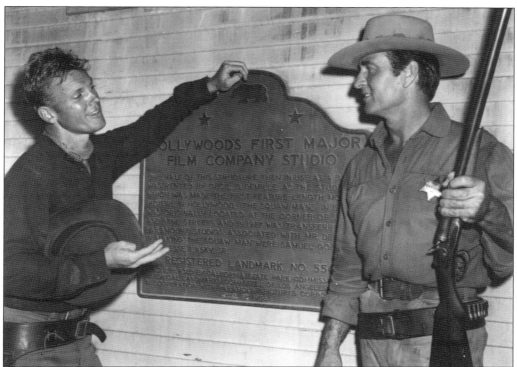

LASKY-DEMILLE BARN, 1967.
Tab Hunter (left) and George
Montgomery take a break from
filming the Western *Hostile Guns*
outside of the Lasky-DeMille
Barn, which was part of the
Western Town set. The actors
stand in front of a plaque that
was dedicated on December 27,
1956, naming the barn a historic
landmark for its part in the filming
of the first feature-length film
shot in Hollywood—by the Lasky
Feature Play Company in 1913.

**DESILU-PARAMOUNT MERGING
OF STUDIO LOTS, 1967.** Gulf +
Western CEO Charles Bluhdorn
and Lucille Ball cut a film strip
to commemorate the sale of her
Desilu Studios to Paramount. The
studios, which were adjacent to
each other, would be combined
into one lot, and the deal would
give Paramount ownership of the
Desilu shows *Mission Impossible*, *Star
Trek*, *Mannix*, and *The Lucy Show*.

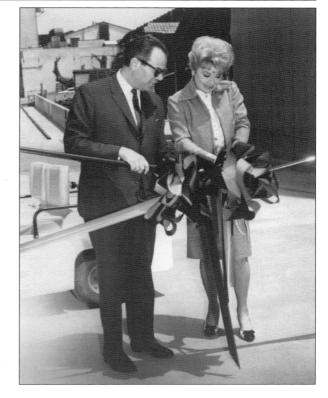

ROBERT EVANS, 1967. When Charles Bluhdorn hired Robert Evans to run Paramount, they were in last place among the major studios of Hollywood. The press had a field day with the idea that Paramount would hire an ex-actor and inexperienced producer to restore them to greatness—but that is just what he did. With a keen eye for a story and appealing to a new audience of moviegoers, Evans saved the studio from ruin.

THE ODD COUPLE, 1968. Gene Saks directs Jack Lemmon and Walter Matthau in the fourth highest grossing film of 1968. *The Odd Couple* was the $40 million box office smash Paramount needed to launch its rise back to the top. Billy Wilder was originally asked to direct the film, but he and the studio couldn't come to terms on his salary, so Paramount chose in-house director Saks instead.

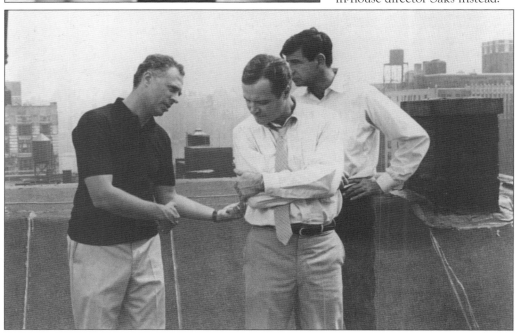

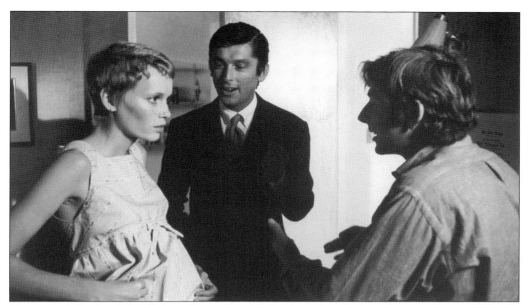

ROSEMARY'S BABY, 1968. Robert Evans (center) brought in unknown director Roman Polanski (right) to helm *Rosemary's Baby.* They are pictured here with the film's star, Mia Farrow (left). *Rosemary's Baby* proved to be another box office success for Paramount, grossing over $30 million. In 2014, the film was selected by the Library of Congress to be preserved in the National Film Registry.

DRESSING ROOM BUILDING, 1968. Paramount's biggest stars were awarded these apartment-type dressing rooms on the lot. Since the industry has changed and most stars now use private trailers, these dressing rooms are now used as office space.

ADMINISTRATION BUILDING PROMENADE, 1968. Looking west, the Administration Building is on the left, and the Production Park parking lot can be seen at the end of the promenade. The Paramount Western Street is visible in the background.

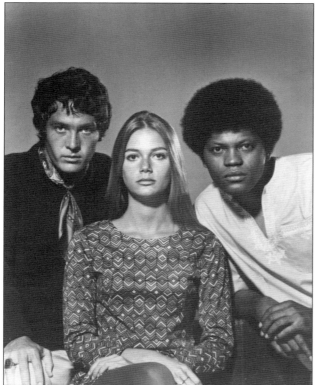

THE MOD SQUAD, 1968. This Aaron Spelling/Danny Thomas produced show starred (from left to right) Michael Cole, Peggy Lipton, and Clarence Williams as three young, hip, undercover detectives. It was one of the first shows to feature an African American leading man. The show was filmed on Paramount's Stage 23 the first three of its five seasons and earned several Emmy and Golden Globe nominations, and a Best Actress win at the Golden Globes for Peggy Lipton.

DRESSING ROOM BUILDING, 1968. Here, Avenue M runs toward Stage 5—showing the rear of the Star Dressing Room Building on the right.

STAGES 1-2 & 3, 1968. In this photograph of Avenue P, the Lubitsch Building (formerly the Director-Producers Building) is on the left, and the oldest stages on the lot—Stages 1 and 2—are at right. At the end of the street is Stage 4. Stage 1 has hosted such films as the original *The Nutty Professor* and *Love with the Proper Stranger*, while Stage 2 was where Hitchcock's *The Man Who Knew Too Much* and *The Seven Little Foys* were filmed. Stages 1 and 2 are the current home of the crime series *Rizzoli & Isles*.

NEW YORK STREET, 1968. This view of New York Street shows the cables overhead used to draw canvas tarps over the street. These tarps help diffuse the harsh lighting created by the floodlights atop the buildings.

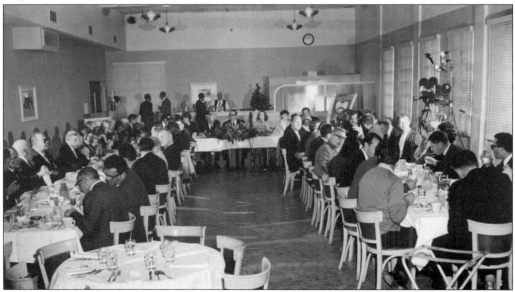

CAFÉ CONTINENTAL, 1964. Press conferences called to publicize a star or a new release were regularly held in the commissary. This image shows a press conference for the film *Where Love Has Gone*, with producer Joseph E. Levine, studio executive Jacob Karp, Bette Davis, Susan Hayward, and costume designer Edith Head seated at the head table.

DESILU MILL BUILDING, 1968. This former RKO-Desilu building is one of many that have been reconstructed, modernized, and expanded since the merger with Paramount in 1967.

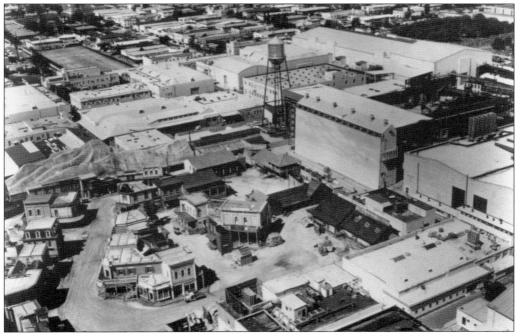

PARAMOUNT LOT, 1968. This aerial view shows Western Town, "B" Tank, and the recently merged Desilu lot to the west. The Western Town set was first built in 1948, but it was enlarged in 1955 and renamed Virginia City, since it was the home of the television show *Bonanza* for many years.

PARAMOUNT GOWER LOT, 1968. Looking north along Avenue "C," the Studio Recording Stage—in Stage 22—and the Directors Building are on the right. Stages 30 and 31 are at the end of the street. These former RKO stages were used for the making of *Top Hat* (1935) and *Citizen Kane* (1941).

WINDSOR GATE, 1969. Studio Tour Guides pose at the Windsor Gate, off of Melrose Avenue. This gate was used mostly for production trucks and cars that needed convenient entry onto the lot. There were also VIP tours that began here that were not generally open to the public. The guides would show guests the Western Town, New York Street, and some film production facilities around the lot.

PRODUCTION PARK, 1969. Robert Evans and vice president of production Bernard Donnenfeld take a few minutes to pose in front of the Producers Building (Schulberg Building) with some of the Paramount stars filming on the lot. Pictured from left to right are (first row) Lee Marvin, Evans, Barbra Streisand, Donnenfeld, and Clint Eastwood; (second row) Rock Hudson, John Wayne, and Yves Montand.

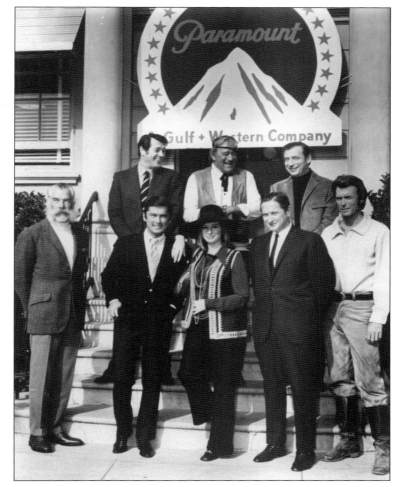

PARAMOUNT LOT, 1969. Looking north to Stage 5, the Dressing Room Building is at left, and the Production Building is on the right. The Production Building was renamed the Schulberg Building in honor of B.P. Schulberg, who discovered Clara Bow. One of the studio's makeup departments was in the Dressing Room Building, and production managers and producer offices were located in the Production Building.

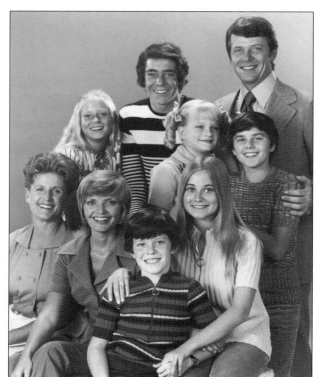

THE BRADY BUNCH, 1969–1974. Stage 5 was home to one of America's favorite families, *The Brady Bunch*. During its initial run, the show wasn't a ratings champ, but people related to the family with six kids. The series ended in 1974, went into syndication a year later, and has not been off the air in over 40 years. The original show has sparked several reunion specials, a cartoon, a stage play, a variety series, and several feature films.

RKO-DESILU ELECTRICAL BUILDING, 1969. This former RKO-Desilu electrical supply building once housed electrical lighting equipment and maintenance shops. When Paramount took over the Desilu lot, the building was cleaned, painted, and equipped for new use.

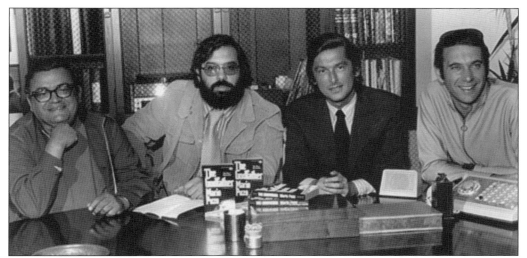

THE GODFATHER, 1969. At the press conference announcing the beginning of production for *The Godfather* were, from left to right, the book's author, Mario Puzo; director, Francis Ford Coppola; Paramount's head of production, Robert Evans; and producer Albert Ruddy. *The Godfather* would meet with some resistance from groups that didn't want to see the film made, but Paramount refused to buckle. The result was one of the most iconic movies in film history.

GOODBYE, COLUMBUS, 1969. Richard Benjamin and Ali MacGraw starred in this adaptation of the Philip Roth novella, which became another important film for the studio. Grossing over $20 million worldwide, *Goodbye, Columbus* became one of the most popular films of the year. MacGraw's portrayal of Brenda Patimkin led her to become "America's Sweetheart." She was awarded the "Most Promising Newcomer of the Year" at the 1970 Golden Globes and would also win a Laurel Award and be nominated for a BAFTA. In three short years, movie exhibitors would vote her the top female box office star in the world.

DRESSING ROOM BUILDING, 1969. Built in 1926, this building was designed in various European styles and could double as a set or as a three-story dressing room unit. Stars such as Mae West, William Holden, Marlene Dietrich, and Clara Bow had a "unit" in this building. Each unit would have an office on the ground floor and rooms for personal use on the upper two floors.

PRODUCTION PARK, 1969. Pictured on the left is the Production Building, where production managers planned the making of films. To its right is the Directors-Producers Building, where Billy Wilder had his office when making *Sunset Boulevard* in 1949. At the time of this photograph, Production Park was a parking lot. In the 1980s, it was reinstated as a park.

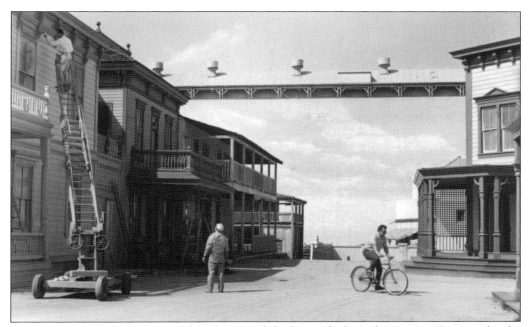

PARAMOUNT "B" TANK, 1969. This photograph looks north through Western Town to the sky backing. This portion of the Western Town was located in the "B" Tank for several years. From time to time, the "B" Tank was filled with dirt to expand ground-based sets. When the tank was needed for water scenes, the dirt had to be removed. To assure continuity on shows like *Bonanza*, which filmed here on a regular basis, the sets had to be maintained often. Note the painter on the left.

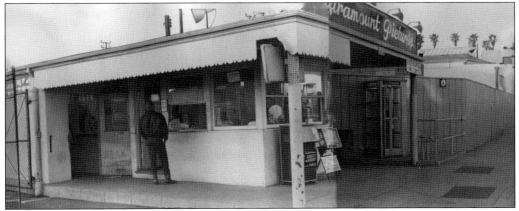

VAN NESS GATE, 1969. The security shack at the Van Ness Gate was used to monitor the movement of vehicles in and out of the lot. It was enlarged in the 1980s and continues to be one of the most important entrances for vehicles and visitors alike.

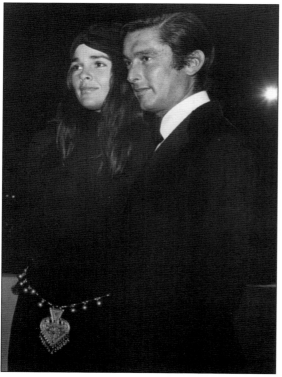

TRUE GRIT, 1969. John Wayne made 181 films, but it was Paramount's *True Grit* that won him an Oscar and Golden Globe for Best Actor. Before Glen Campbell took on the role of La Boeuf, Clint Eastwood was considered for the role—but he turned it down due to another commitment.

ALI MACGRAW AND ROBERT EVANS, 1969. In October 1969, Ali MacGraw and Robert Evans attend the premiere of *Paint Your Wagon*. After the success of *Goodbye, Columbus*, Paramount was set to make *Love Story* with MacGraw. However, Ali didn't like the choice of Arthur Hiller as director. Evans invited MacGraw to screen one of Hiller's films at his home, and while he was giving Ali a tour of the house she jumped into the pool with all her clothes on—and didn't leave. MacGraw and Evans married in Palm Springs on October 24, 1969, a few weeks after this photograph was taken.

Four

1970–1979

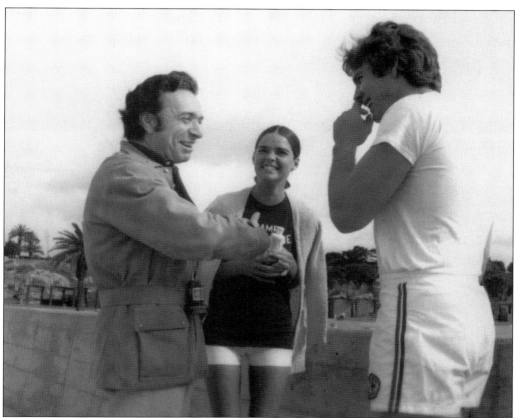

LOVE STORY, 1970. Arthur Hiller directs Ali MacGraw and Ryan O'Neal in the film that taught us "love means never having to say you're sorry." Robert Evans knew that he had a hit, and *Love Story* proved him right by becoming the highest grossing film of the year—bringing in $160 million worldwide and restoring Paramount to prominence. The film was nominated for seven Academy Awards, and Francis Lai won for his musical score. *Love Story* also took home five Golden Globes for Best Picture, Director, Screenplay, Original Score, and Ali MacGraw won for Best Actress and landed on the cover of *Time* magazine.

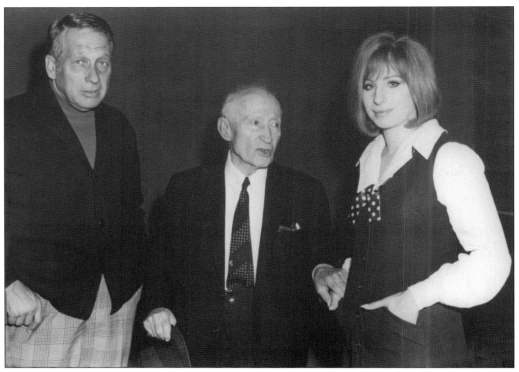

ON A CLEAR DAY YOU CAN SEE FOREVER, 1970. This on set photograph shows, from left to right, producer Howard Koch, Adolph Zukor, and Barbra Streisand. When Robert Evans wanted to purchase *Funny Girl* to star Streisand he was told no by Charlie Bluhdorn. After the success of *Funny Girl* for Columbia, Paramount needed to find a vehicle for Streisand, and *Clear Day* was it. Evans would also cast Jack Nicholson in this film—starting a lifelong friendship.

MANNIX, 1972. A popular hour-long crime drama for Paramount Television, *Mannix* starred Mike Connors as private detective Joe Mannix and Gail Fisher as his assistant, Peggy Fair. Fisher won an Emmy and two Golden Globes for her role, and Connors took home one Golden Globe.

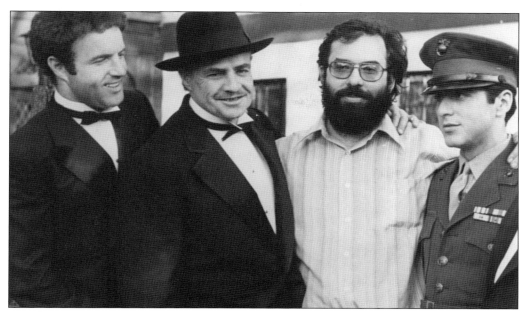

THE GODFATHER, 1972. From left to right, James Caan, Marlon Brando, Francis Coppola, and Al Pacino pose on the set of *The Godfather.* The highest grossing film of the year, it was nominated for 11 Academy Awards and won three. To convince the studio to hire Brando, Coppola tricked the greatest actor of his time into taking a screen test by telling him that the studio wanted a makeup test. When the executives saw Brando in action, they hired him for scale plus a small percentage of the profits, which Brando sold back before the film came out. This eventually cost him $11 million.

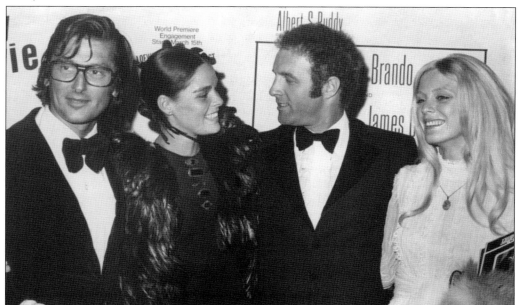

THE GODFATHER PREMIERE, 1972. Not even a blizzard could keep (from left to right) Robert Evans, Ali MacGraw, James Caan, and his date from attending the premiere of *The Godfather* on March 14, 1972, at the Loews State Theatre in New York City.

STAGES 8 AND 9, 1973. This photograph looks north to the shop area of the lot, which borders the Hollywood Forever Cemetery. On the left is the present-day Dreier Building that fronts Stages 8 and 9, which were later known as the *Star Trek* stages. The building housing the two stages was built in 1919 by the Brunton Studio Company.

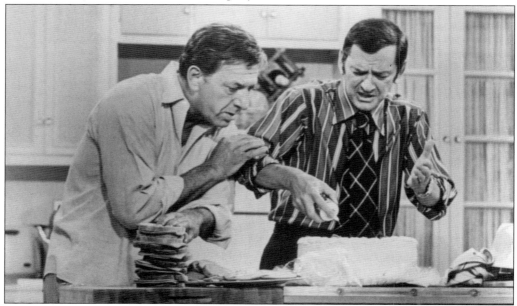

THE ODD COUPLE, 1970. Based on Neil Simon's play, Garry Marshall and his longtime writing partner Jerry Belson were the creators of *The Odd Couple* series for Paramount Television. Filmed on Stage 19, Tony Randall (right) starred as Felix opposite Jack Klugman (left) as Oscar. Beginning with season two, upon Randall's insistence, the show was filmed before a live audience to add more energy to the jokes. Both Randall and Klugman were awarded Emmys for their roles in the comedy, which is still airing in syndication.

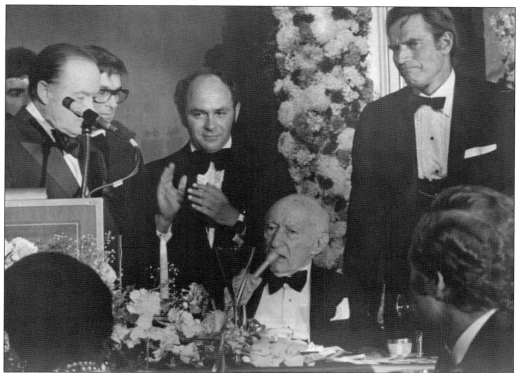

ADOLPH ZUKOR, 1973. On hand at Paramount founder Adolph Zukor's 100th birthday party are (from left to right) host Bob Hope, Robert Evans, Frank Yablans, Zukor (seated), and Charlton Heston. Zukor would remain chairman emeritus until his death from natural causes on June 10, 1976.

PAPER MOON, 1973. Director Peter Bogdanovich chose real-life father and daughter Ryan and Tatum O'Neal to play Moze and Addie Prey in *Paper Moon*. The film was nominated for four Academy Awards, with 10-year-old Tatum winning Best Supporting Actress—the youngest person to ever win an Oscar.

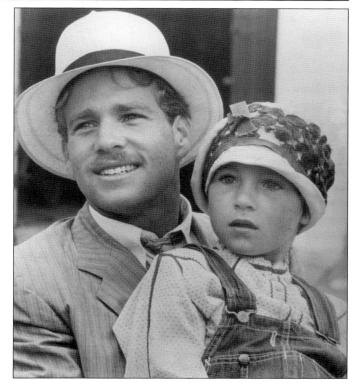

LUCY PARK, 1973. Pictured are the original executive offices of RKO and Desilu Studios. The bow window on the second floor was the office Lucille Ball occupied when she owned the lot. Paramount acquired Desilu in 1967, and the building was eventually renamed the Lucille Ball Building in her honor. During his ownership of RKO, Howard Hughes also occupied offices on the second floor.

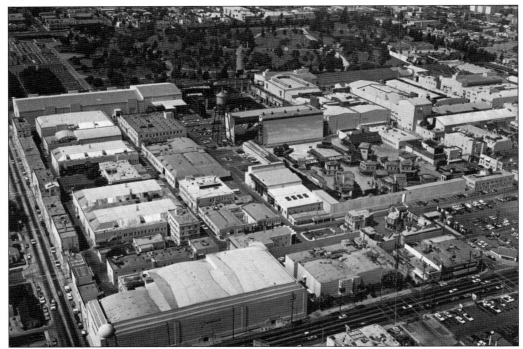

AERIAL VIEW, 1973. Looking north from the intersection of Gower Street and Melrose Avenue, Stages 21, 20, and 19 are visible at bottom left. The original RKO-Desilu lot—at left—was merged with the Paramount lot in 1967. In the center of the studio lot is the "B" Tank, with the Western Street dominating the heart of the backlot.

THE GODFATHER PART II, 1974.
Francis Ford Coppola and Al
Pacino are pictured on location
for Paramount's highest grossing
film of 1974. The 11-time
Academy Award–nominated
film took home six Oscars,
including Best Picture. Troy
Donahue played the character
Merle Johnson, which was
Donahue's actual birth name.
Ranked the 32nd greatest
American movie of all time by
the American Film Institute,
The Godfather Part II is preserved
by the Library of Congress in
the National Film Registry.

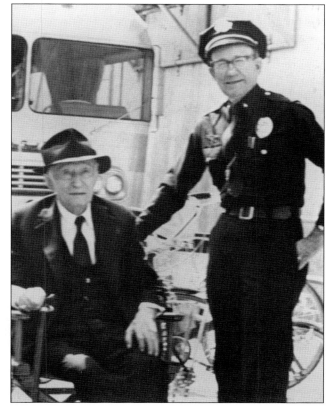

ADOLPH ZUKOR, 1974. Longtime
Paramount police officer "Fritz"
visits with his friend Adolph
Zukor on the studio lot. Even
though Zukor was semiretired, he
continued to visit the Paramount
lot over the years, watching over
the studio and its personnel.

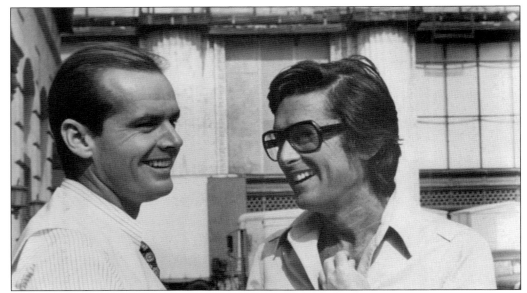

CHINATOWN, 1974. Producer Robert Evans (right) visits Jack Nicholson on the New York Street set, which served as 1930's Los Angeles during the making of *Chinatown*. This was Evans's first outing as an independent producer. *Chinatown* earned 11 Oscar nominations and one win for the Robert Towne–written, Roman Polanski–directed masterpiece. The film also took home four Golden Globes for Best Film, Director, Actor, and Screenplay.

HAPPY DAYS, 1974–1984. From left to right, cast members Donny Most, Henry Winkler, Anson Williams, and Ron Howard pose outside of Arnold's Diner—the show's fictional burger joint. Arnold's was set up at the rear of the lot, near the Van Ness gate. The Garry Marshall–created show was shot on Stage 19 for most of its 11 seasons and was filmed before a live audience in all but its first two seasons.

THE BAD NEWS BEARS, 1976. Michael Ritchie directs Academy Award winners Walter Matthau and Tatum O'Neal in this classic baseball movie. Burt Lancaster's son Bill wrote the script and won a Writers Guild award for showing the ups and downs of sportsmanship in Little League baseball. The success of this film sparked two sequels, a television series, and a 2005 remake.

MARATHON MAN, 1976. Robert Evans (right), the producer of *Marathon Man*, visits his longtime friend and star of the film, Dustin Hoffman, on the set. The film costarred Laurence Olivier, who was nominated for an Oscar and won a Golden Globe for playing the part of a Nazi war criminal. While the Method-acting Hoffman was discussing staying up for three days to prepare for a scene, Olivier famously asked, "Why not just act it," before laughingly adding, "I'm one to talk."

W.C. FIELDS AND ME, 1976. Rod Steiger, the star of *W.C. Fields and Me*, is shown filming a location scene just outside the Bronson Gate. The film was based on the book of the same name detailing Fields's romance with Carlotta Monti. Directly behind Steiger is the popular eatery Oblath's Studio Café, which was frequented by many of Paramount's stars and employees.

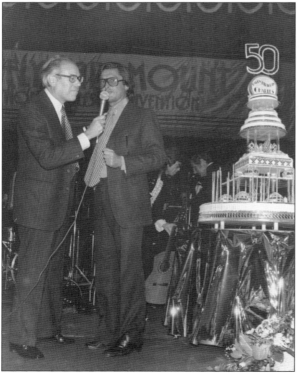

CHARLES BLUHDORN, 1976. Robert Evans (right) throws Charles Bluhdorn a 50th birthday party at the Paramount Pictures Sales Convention. A notorious workaholic, Charlie Bluhdorn died at the age of 56 in 1983—suffering a fatal heart attack aboard his private plane while returning from vacation.

SATURDAY NIGHT FEVER, 1977. John Travolta's breakout film was directed by John Badham and costarred Karen Lynn Gorney. It was such a colossal hit that Paramount had to re-edit the movie and offer a PG version as an alternate to the R-rated film, so younger audiences could see it. The soundtrack, which was mostly songs by the Bee Gees, sold over 15 million copies and stayed on the *Billboard* charts for 120 weeks.

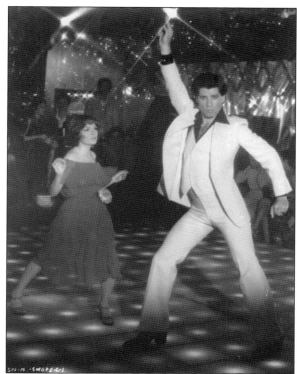

GARRY MARSHALL, 1978. Producer Garry Marshall is pictured at center, in the front of the William S. Hart Building on the Paramount West Lot, with his stars Ron Howard, Penny Marshall, Cindy Williams, Robin Williams, Pam Dawber, and Henry Winkler. All the shows Marshall created were filmed at Paramount: *Happy Days* on Stage 19, *Laverne & Shirley* on Stage 20, and *Mork & Mindy* on Stage 26. They all dominated in the ratings.

TAXI, 1978. The original cast of *Taxi* included, from left to right, (bottom row) Tony Danza, Marilu Henner, (second row) Jeff Conaway, Randall Carver, (standing) Andy Kaufman, Danny DeVito, and Judd Hirsch. The characters worked for the Sunshine Cab Company in New York City and were created by former *Mary Tyler Moore Show* staffers Ed. Weinberger, David Davis, Susan Daniels, James Burrows, and James L. Brooks for ABC Television. The show won 18 Emmy Awards in its five seasons and was selected by *TV Guide* as one of the 50 greatest shows of all time.

GREASE, 1978. John Travolta urged the producers to hire Olivia Newton-John for this film adaptation of the successful Broadway show. The chemistry paid off, with the opening weekend box office reaching almost $9 million. At the time, it was the highest grossing musical in history.

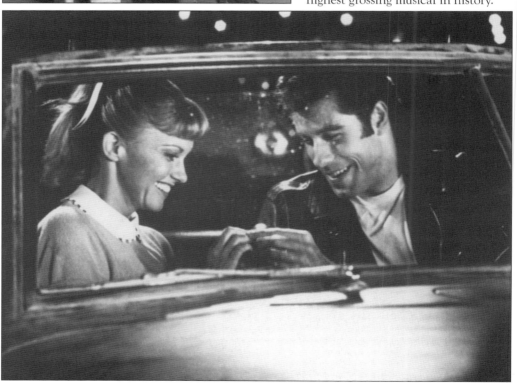

GOWER STREET ENTRANCE, 1978.
Out of the Blue filmed on Stage 25
and starred comedian Jimmy Brogan,
along with the twins Shane (left)
and Jason Keller, pictured with their
mother, Harriet. The show was a
crossover of *Happy Days* and *Mork
& Mindy*. Some years later, Brogan
would become the head writer for
Jay Leno's *Tonight Show*. (Photograph
courtesy of Harriet Keller.)

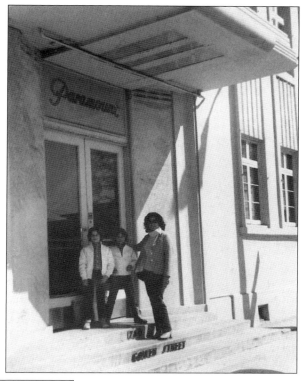

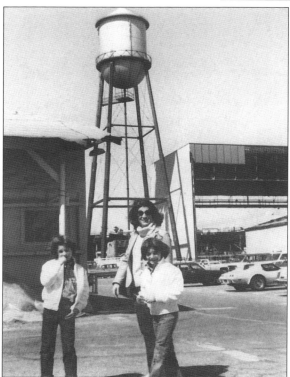

PARAMOUNT WATER TOWER, 1978.
Shane (left) and Jason Keller—on
a break from filming *Out of the
Blue*—take a photograph with their
mom, Harriet. When the show was
canceled, Garry Marshall approached
the boys about playing Fonzie's twin
nephews on *Happy Days*, but they
missed their friends and school and
decided to return to New York. Shane
would later return to Paramount as
a producer for the Scott Baio show
See Dad Run. He currently produces
the show *Nicky, Ricky, Dicky &
Dawn* on Stage 19. (Photograph
courtesy of Harriet Keller.)

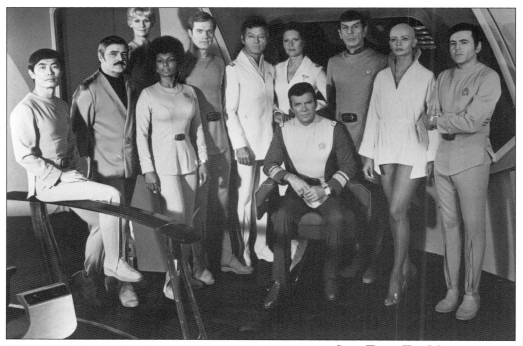

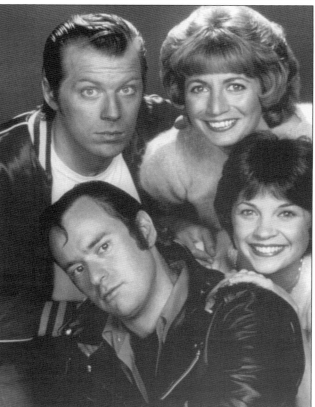

STAR TREK: THE MOTION PICTURE, 1979. Directed by Robert Wise, the crew of the *Enterprise* were reunited to combat a lethal force field headed toward Earth. The principal cast included (from left to right) George Takei, James Doohan, Majel Barnett, Nichelle Nichols, Stephen Collins, DeForest Kelley, Grace Lee Whitney, William Shatner, Leonard Nimoy, Persis Khambatta, and Walter Koenig.

LAVERNE & SHIRLEY, 1976–1983. With this spinoff of *Happy Days*, executive producer Garry Marshall successfully created a new show that became one of the most successful television shows in Paramount's history. Filmed on Stage 20, the show starred Marshall's sister Penny Marshall as "Laverne," Cindy Williams as "Shirley," and Michael McKean and David L. Lander as their neighbors "Lenny" and "Squiggy."

Five

1980–1989

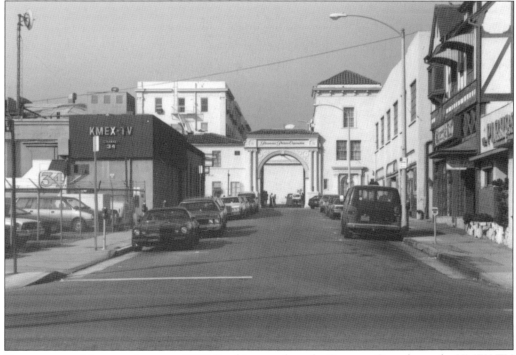

BRONSON AND MELROSE AVENUE, 1980. Looking north to the Bronson Gate shows the KMEX TV Channel 34—located in the former KTLA Studios at Marathon Street and Bronson Avenue—on the left, and the Playboy and Sherry's Bars on the right.

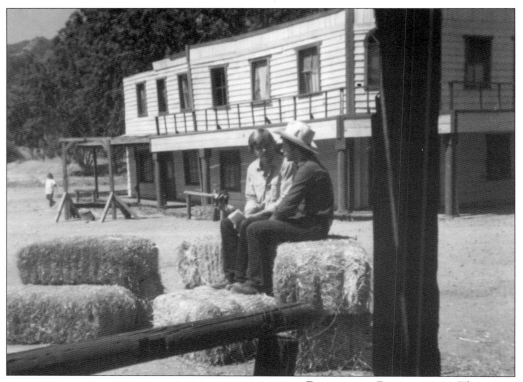

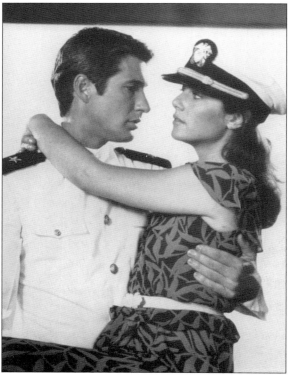

PARAMOUNT RANCH, 1981. The
National Park Service acquired the
former Paramount Ranch in 1980. The
following year, the Ranch was formally
opened, with *The Sunday Show's* Pat
Sajak interviewing historian and
coauthor Marc Wanamaker about
Paramount Ranch's history and
the films made there. Paramount
originally acquired the Ranch in
1926 and sold it in 1948. Later, it was
purchased by William Hertz, who built
the current Western Town set that was
used by the television show *Dr. Quinn:
Medicine Woman* from 1992 to 1997.

**AN OFFICER AND A GENTLEMAN,
1982.** Directed by Taylor Hackford
and starring Richard Gere and
Debra Winger, *An Officer and a
Gentleman* is a story of two misfits
who seek direction in their lives.
Louis Gossett Jr. won an Oscar
for his supporting role in this very
popular film, which broke many
box office records for Paramount.

SKY BACKING AND "B" TANK, 1983. Paramount's "B" tank is used by the producers of *The Winds of War*—a television miniseries starring Robert Mitchum. Built in 1947, the tank and sky backing were used for special-effects shots in the 1956 Cecil B. DeMille epic *The Ten Commandments*, during the "parting of the Red Sea" scenes.

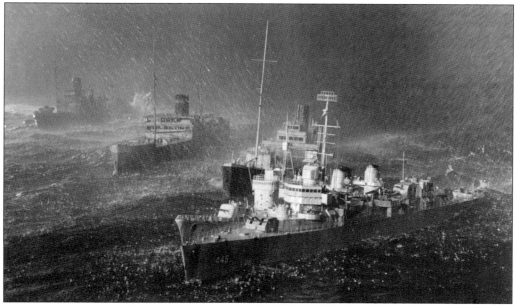

"B" TANK, 1983. Herman Wouk adapted his World War II novel *The Winds of War* into a television miniseries that aired in 1983. One of the biggest miniseries productions of all time, it included 1,785 scenes that were filmed in 267 locations in six countries, over a 14-month span. The "B" Tank was used for much of the miniature work, re-creating many of the naval battles of the war.

PARAMOUNT STUDIOS, 1983. Looking northwest to Van Ness and Melrose Avenues, the present Raleigh Studios are at the bottom right of this photograph—with Paramount in the center.

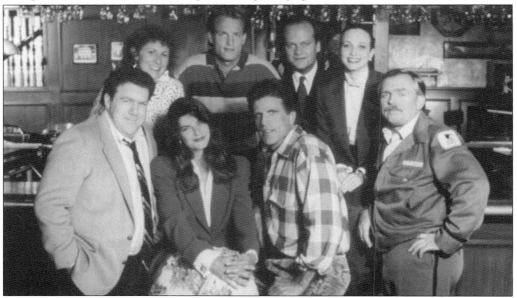

CHEERS, 1982–1993. Pictured is the cast of the hit comedy *Cheers*. From left to right are (first row) George Wendt, Kirstie Alley, Ted Danson, John Ratzenberger; (second row) Rhea Perlman, Woody Harrelson, Kelsey Grammer, and Bebe Neuwirth. *Cheers* was created by the same team behind *Taxi*. Filmed on Stage 25, it won 28 Emmy Awards and was ranked in the top 10 shows in eight of its 11 seasons. When *Cheers* ended, Grammar never had to leave Stage 25, as his character was spun off into the hit series *Frasier*, which won 37 Emmy Awards. Grammar has the rare distinction of playing the same role for 20 years.

NEW YORK STREET FIRE, 1983. A fire swept through the northwestern corner of the New York Street set on August 25, 1983, damaging external sets and one soundstage. A 500-by-500-foot area was destroyed, which included the exterior sets "New York Street," "Boston Street," and "Church Street."

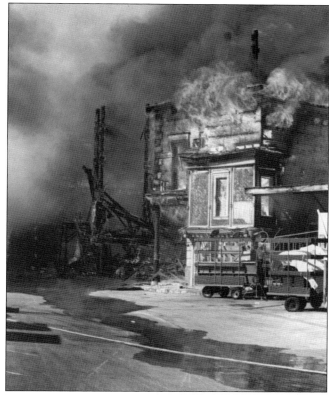

NEW YORK STREET FIRE, 1983. Soundstages 12, 14, 15, and 16—all concealed behind the false fronts of New York Street—seemed particularly threatened at the height of the fire, but they actually sustained relatively minor damage. Stage 16 was slightly damaged, and Stage 15—which contained a major set for *Star Trek III: The Search for Spock* at the time—was slightly scorched but not seriously damaged.

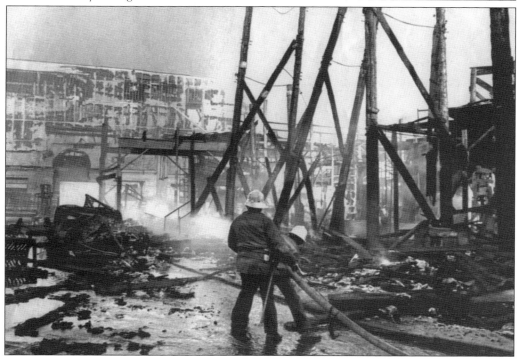

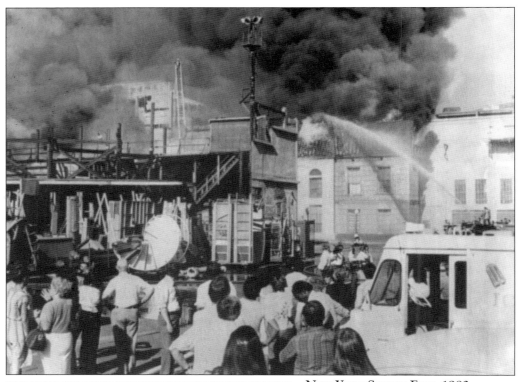

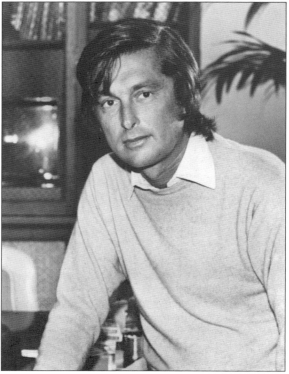

NEW YORK STREET FIRE, 1983.
William Shatner, star of *Star Trek III*,
was one of several cast members
who hosed down the inside wall of
the stage until the firemen arrived.
By October 7th, the fire department
had blamed the fire on arson. The
areas that were destroyed were where
The Godfather, *The Godfather Part II*,
and *Chinatown* were once filmed.

ROBERT EVANS, 1984. In 1975, Robert
Evans left his job as Paramount
chief to become one of the most
successful independent producers
of all time, putting together a string
of moneymakers that included
Black Sunday, *Urban Cowboy*,
Popeye, *Sliver*, *Jade*, and *The Saint*.
He is the only living producer to
have four films selected by the
Library of Congress for inclusion
in the National Film Registry.

BEVERLY HILLS COP, 1984. From left to right, Eddie Murphy, Judge Reinhold, and John Ashton are pictured in a scene from *Beverly Hills Cop*. This was the first time Murphy had to carry the lead role in a film, and he proved worthy of the challenge. *Beverly Hills Cop* was the highest grossing movie of 1987.

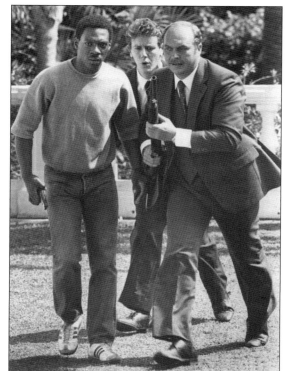

RONALD REAGAN VISITS THE STUDIO. Eddie Murphy introduces comedian John Witherspoon (right) to Paramount producer A.C. Lyles and President Reagan during Reagan's visit to the lot. Reagan, a close friend of Lyles, starred in three pictures for Paramount: *The Last Outpost* (1951), *Hong Kong* (1951) and *Tropic Zone* (1953).

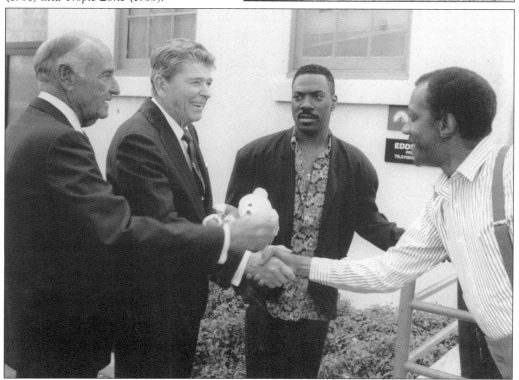

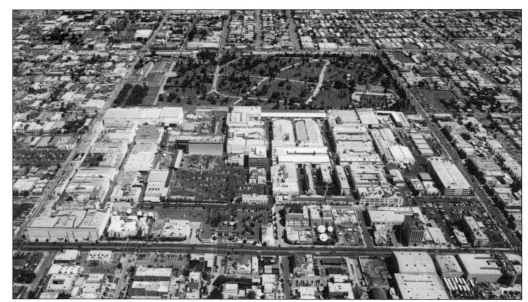

PARAMOUNT STUDIO, 1985. This photograph shows Paramount Studios with the Hollywood Forever Cemetery to the north. The studio was constructed in 1917 on what was originally cemetery property. Today, there is a wall separating the cemetery from the backlot of Paramount.

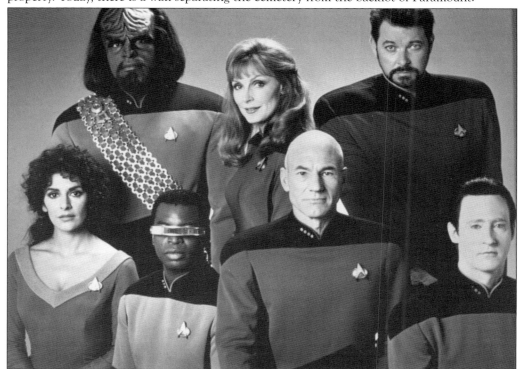

STAR TREK: THE NEXT GENERATION, 1987–1994. Pictured here, the cast of *Star Trek: The Next Generation* included, from left to right (first row), Marina Sirtis, LeVar Burton, Patrick Stewart, and Brent Spiner; and (second row) Michael Dorn, Gates McFadden, and Jonathan Frakes.

THE BRONX ZOO, 1987–1988. The Bronx's Benjamin Harrison High School was the setting for this Paramount television show, which aired on NBC and starred Edward Asner, Joe Danzig, Kathryn Harrold, Nicholas Pryor, Kathleen Beller, Mary Caitlin Callahan, David Wilson, Mykel T. Williamson, and Jerry Levine. The facade of the high school was attached to Stage 15 and is now part of the current New York Street.

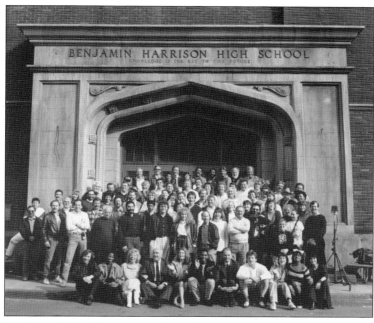

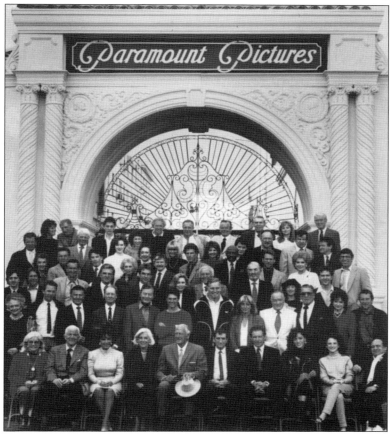

PARAMOUNT'S 75TH ANNIVERSARY, 1987. In 1987, stars from Paramount's film and television history came to the studio lot to pose for a group photograph in front of the Bronson Gate. Pictured among this group are Charlton Heston, Robert De Niro, Janet Leigh, Ali MacGraw, Burt Lancaster, Glenn Ford, Leonard Nimoy, Gregory Peck, Charles Bronson, Olivia de Havilland, Elizabeth Taylor, Bob Hope, and Tom Cruise.

NEW WINDSOR GATE, 1988. After the reconstruction of the studio lot and the installation of Paramount's Marathon Street Promenade, a new drive-in gate was needed. Since the old Bronson Gate could no longer accommodate vehicular traffic, the solution was this new double-arched Windsor Gate, which was constructed on Melrose Avenue.

MEDICAL BUILDING, 1989. This photograph shows the hospital and Stage 17 on Avenue P. Built in 1927, the hospital was one of the earliest buildings constructed on the lot. Recently renamed the Medical Services Building, it is a miniature emergency hospital that can stabilize a patient until additional medical help arrives. It was also used as Kelly McGillis's home in the film *Top Gun*.

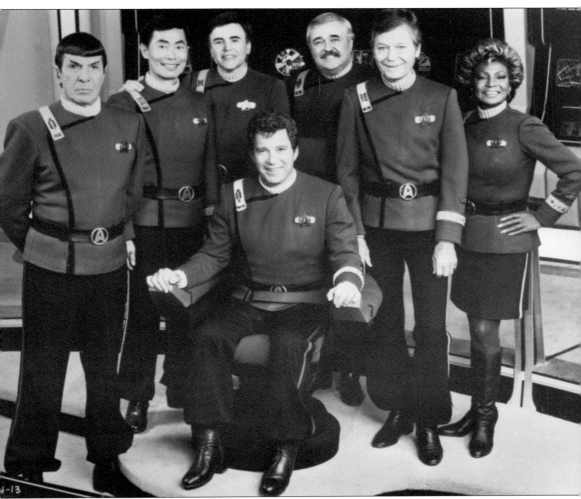

***Star Trek V: The Final Frontier*, 1989.** William Shatner (seated) directed and starred in this installment of the popular series. With him, from left to right, are Leonard Nimoy, George Takei, Walter Koenig, James Doohan, DeForest Kelley, and Nichelle Nichols.

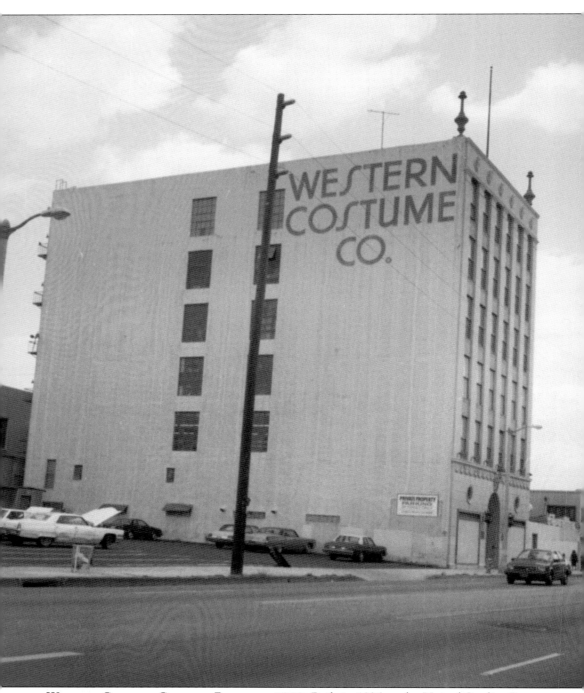

WESTERN COSTUME COMPANY BUILDING, 1989. Built in 1926 as the United Studios Property and Costume Company, this building became the Hollywood unit of downtown Los Angeles's Western Costume Company. By 1930, United was sold to Western Costume, and the building survived until Paramount demolished it in the 1980s—forcing Western Costume to relocate to North Hollywood.

Six

1990–2000

"B" TANK AND WATER TOWER, 1990. The new Sky Backing adjacent to the "B" Tank was constructed out of steel and concrete, with a new state-of-the-art film storage facility built into the rear of the structure.

"B" TANK, 1990. This photograph shows the construction of a new Sky Backing adjacent to the "B" Tank after the old wooden structure was declared unsafe and unstable. The original Sky Backing was used in countless films and television shows after its construction in 1947.

PARAMOUNT BACKLOT, 1990. In this photograph, Stage 13 is pictured at right, opposite the Music Building.

WILLIAM S. HART BUILDING AND PROMENADE, 1990. This photograph looks east, to the Marathon Street Promenade. At the far left is the Paramount restaurant and commissary, and just beyond that is the Paramount Studio Store. The building to the near left was where Gene Roddenberry's office was located on the ground floor, the window to the far right, while he was working on the *Star Trek* series. Garry Marshall took over this office when Roddenberry moved out. Paramount producer A.C. Lyles's office was on the top floor.

STAGES 23 & 24, 1990. These stages were originally part of the former RKO and Desilu lot and have been used predominately by Paramount for television shows. Such classic shows as *Taxi* and *Mod Squad* filmed on Stage 23, and Michael J. Fox's great sitcom *Family Ties* called Stage 24 home.

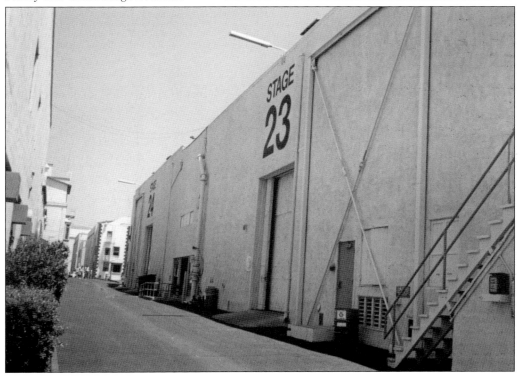

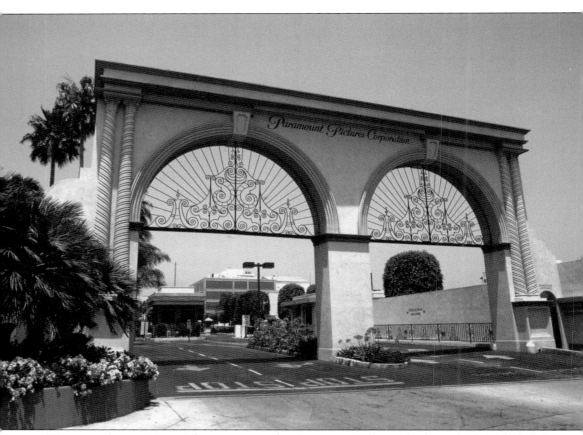

WINDSOR GATE, 1991. After a major redevelopment of the studio lot, which included the transformation of Marathon Street into a pedestrian promenade, the new Windsor Gate was opened as the major entrance to the studio for both vehicles and pedestrians.

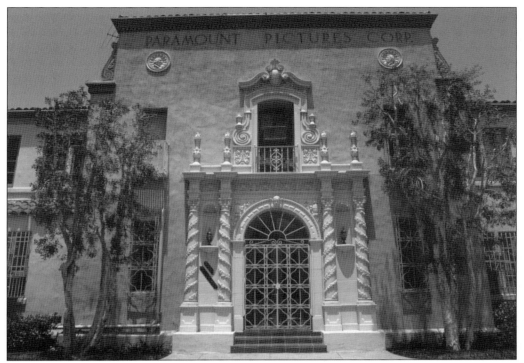

ADMINISTRATION BUILDING, 1991. Built in 1926, when Paramount moved to the former United Studios on Marathon Street, this Spanish Colonial Revival–style building remains the Administration Building for Paramount Pictures to this day. This entrance leads to the administrative offices of the top executives of the company.

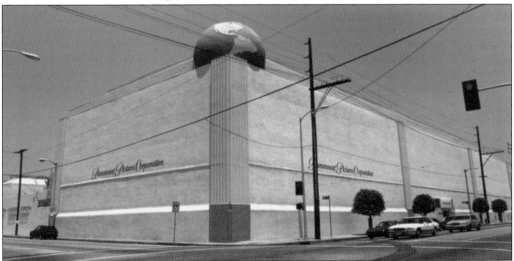

FORMER RKO STAGE AT GOWER STREET AND MELROSE AVENUE, 1991. One of Hollywood's most famous intersections is known for the iconic Earth building cap on the corner of Stage 21. The Earth cap was once the base for the RKO Electric Tower, which stood on top and featured neon lights signaling "RKO." After Desilu took over the studio lot in the mid-1950s, the tower was removed.

NEW YORK STREET CONSTRUCTION, 1991. The New York Street set was expanded at this time, with the addition of more building fronts that could be modified to look like neighborhoods in a number of cities. Here, looking east, one of the main streets is under construction. The high school facade seen in the television series *The Bronx Zoo* is visible in the background.

NEW YORK STREET CONSTRUCTION, 1991. Here, workers put the finishing touches on some New York Street buildings. Special effects features were added to the New York Street, such as rooftop sprinklers for rainy scenes, and steam capabilities for New York street scenes.

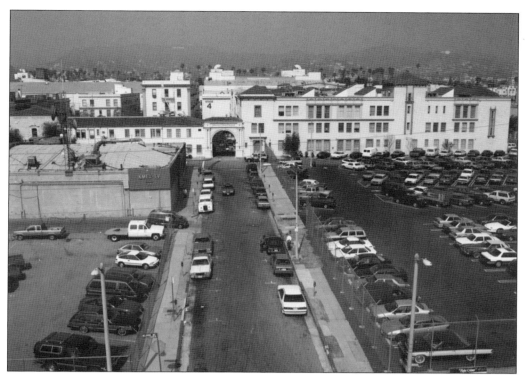

PARAMOUNT STUDIO, 1991. This photograph looks north, from just above Melrose Avenue to the Bronson Gate. Bronson Avenue remained a city street until all of the land fronting Melrose Avenue was purchased and incorporated into the studio lot.

BLUHDORN BUILDING, 1991. Originally, the Bluhdorn Building housed the Paramount wardrobe, casting, and payroll offices. When the Paramount lot was under reconstruction, the building was renamed and converted into studio offices.

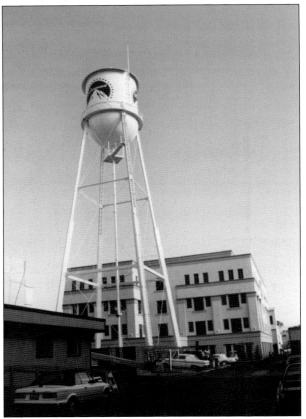

PARAMOUNT WEST LOT, 1991. Looking north, Stage 25 is on the left, and Stages 30 and 31 are at the end of the street. The west side of the Paramount Studios lot was RKO Studios from 1928 to 1957. Desi Arnaz and Lucille Ball purchased it in 1957, renaming it Desilu Studios. After their divorce, Lucille Ball sold the studio in 1967 to Gulf + Western/Paramount, who merged the two lots.

PARAMOUNT WATER TOWER, 1992. Originally, this water tower handled the water pressure for the RKO/Desilu lot's fire suppression sprinkler system. By 1958, after the takeover of Desilu, the Paramount water tower was removed and the Desilu tower was adjusted to handle the water pressure for both lots. The Gene Roddenberry Building—named in memory of the *Star Trek* creator—is visible in the background.

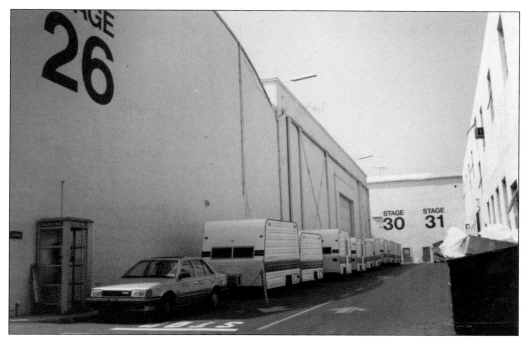

STAGE 26, 1991. Looking north, Stage 26 is pictured on the left, with Stages 30 and 31 at the end of the street. Stage 26 was where Robin Williams filmed *Mork & Mindy*. Filmed on Stage 30 were *Little House on the Prairie* and the Astaire film *Flying Down to Rio,* and Robert Redford made Demi Moore an *Indecent Proposal* on Stage 31. This stage also was used for the original *Star Trek* series and *King Kong* (1976).

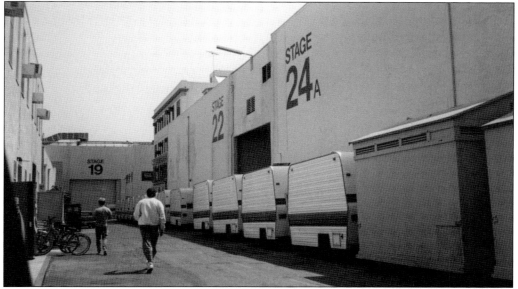

STAGES 22 & 24A, 1991. Looking south to Stage 19—which faces Melrose Avenue on the opposite side—Stages 22 and 24A are on the right. The William S. Hart Building, which was once the RKO Producers Building, is at the end of the street. It is said that Fred Astaire was once given an office there and that he still haunts the top floor.

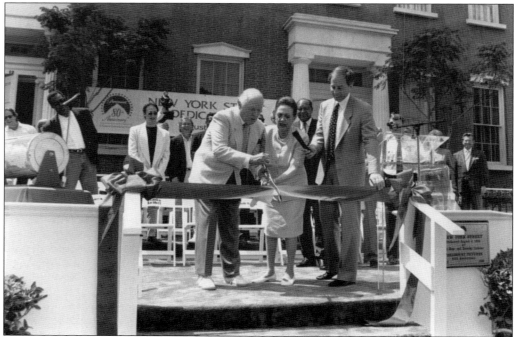

NEW YORK STREET, 1992. Paramount chairman Brandon Tartikoff helps Bob Hope and Dorothy Lamour cut the ribbon at a ceremony rededicating New York Street after an extensive remodeling project. Also in attendance were *Star Trek*'s Brent Spiner, Donald O'Connor, and Mayor Tom Bradley.

NEW YORK STREET, 1992. The newly rebuilt New York Street included various styles of buildings that could double for New York or be re-dressed as other American cities.

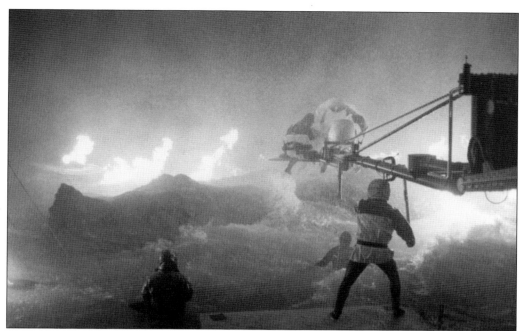

PATRIOT GAMES, 1992. The "B" Tank was used to create special effects scenes for the climactic speedboat fight between Sean Bean and Harrison Ford in *Patriot Games*. To create the scene, the tank was covered, and special scaffolding was installed so the lighting, wind, and rain machines could be precisely controlled.

SHERRY LANSING. After leaving a short career as an actress, Sherry Lansing took a job as a script reader at MGM before eventually working her way to 20th Century Fox and becoming the first woman president of a studio. She then partnered with Stanley Jaffe in their own production company and produced films such as *Fatal Attraction*. In 1992, she was offered the position of CEO at Paramount. In the 12 years she headed the studio, Paramount had some of its greatest success with blockbusters like *Forrest Gump*, *Titanic*, and *Braveheart*.

SUMNER REDSTONE, 1993.
Sumner Redstone left a successful law career in 1954 to run his family's chain of movie theaters (National Amusements). He became a stockholder in several movie studios over the years, and by 1987 he was the controlling partner in Viacom. Viacom was a subsidiary of CBS, but the two companies split in 1971. By February 1994, Redstone's Viacom finalized a plan to purchase Paramount Communications for $10 billion. Six years later, Redstone purchased Viacom's former parent company, CBS, for $40 billion. Redstone remains the chairman and primary stockholder in all of these companies. In June 2012, a ceremony was held renaming the Paramount Pictures Administration Building for Redstone.

RODDENBERRY BUILDING, 1993. Gene Roddenberry became a celebrated and world-famous science fiction writer with the creation of his *Star Trek* television series and films, almost all of which were made on the Paramount lot. When Roddenberry passed away in 1991, one of the newest office buildings on the lot was named after him.

Lucy Park, 1993. This studio park is bordered by Stage 25 at left, which was where *The Lucy Show* was produced and where Lucille Ball's dressing room was located. At center is the Chevalier Building, which was originally the Robertson-Cole, F.B.O. and RKO Studios Administration Building. This building was used as a high school in many series, including *The Brady Bunch* and *Happy Days*.

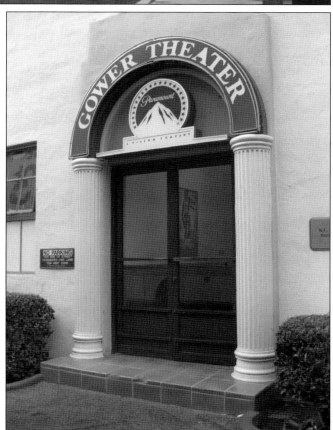

Gower Theater, 1993. The Gower Theater, located on the second floor of the W.C. Fields Building directly across from Stages 23 and 24, is still in use. The 124-seat theater once served as the main screening room for RKO and Desilu Studios. Classic film and television shows like Orson Welles's *Citizen Kane*, Fred Astaire's *Top Hat*, *Star Trek*, and *The Lucy Show* were all screened in this theater.

PARAMOUNT PROMENADE, 1993. At the time this photograph was taken, Paramount had already purchased all of the properties fronting Melrose Avenue and had demolished the Western Costume Company building. At first, the space was used for parking. Later, the Paramount Studio Theatre was built, and a pedestrian promenade replaced the former Marathon Street and Bronson Avenue.

VAN NESS GATE, 1993. Located at the eastern end of the studio lot, the Van Ness Gate was opened in the 1960s at a time when Paramount was purchasing property along Van Ness Avenue. This gate handled most of the large truck traffic, along with general deliveries. By the 1980s, with the construction of a large parking structure nearby, automobile traffic and personnel visitor parking were added.

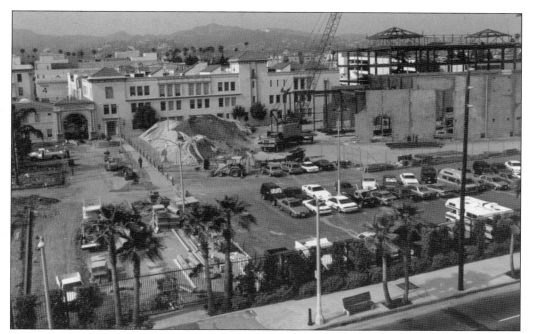

PARAMOUNT STUDIOS, 1993. At the time of this photograph, the Paramount Theater and Marathon buildings were under construction. By the end of 1993, the Paramount south lot had expanded to Melrose Avenue for the first time since 1924, when United Studios occupied the site.

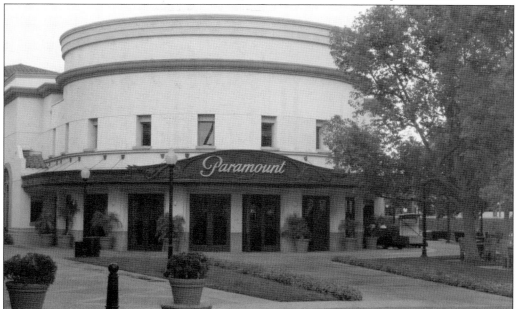

PARAMOUNT THEATRE, 1993. Until 1993, Paramount was using a small studio theater for screenings and events on the lot. With the construction of the new 516-seat Paramount Theatre, there was finally a first-class, state-of-the-art facility on the lot that could handle the needs of a larger audience. Television shows and films like *Glee, Frasier,* and Harrison Ford's *Clear and Present Danger* have all filmed in the huge rotunda lobby.

PRODUCTION PARK, 1993. When Paramount began the reconstruction and modernization of the studio lot in the 1980s, this park had been a parking lot since the early 1960s. Originally, when Paramount moved to this property in 1926, a studio park—called Production Park—was installed and used for studio publicity events. It was surrounded by the Stars Dressing Room Building, the Production Building, and the Directors Building. Today, it is once again a park.

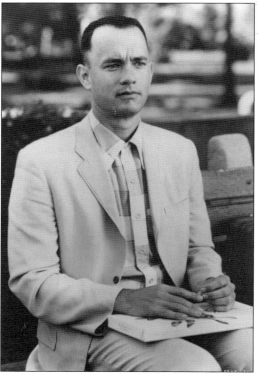

FORREST GUMP, 1994. Tom Hanks is seen sitting on a now-famous park bench in key scenes from this film. The park bench scenes were filmed in Savannah, Georgia, at Chippewa Square. Today, this bench sits on the lot, adjacent to the Paramount Theater, and is an attraction on the Paramount Tour.

PARAMOUNT STUDIO PROMENADE, 1994. The newly opened Paramount Paseo promenade, which was once Marathon Street, is shown in this easterly view. At the end of the Paseo is the Marathon Building, which houses company offices and is adjacent to the Bronson Gate, the Bluhdorn Building, and the Paramount Theater.

PARAMOUNT'S NEW YORK STREET, 1994. This easterly view of the New York Street set shows the former *The Bronx Zoo* high school facade at the end of the street. Above the street are water sprinkler systems to provide "rain" if needed. The new street, rebuilt after the devastating 1983 fire, was designed with fire-proofing in mind. Behind the false frontage, the building was supported with steel beams, sprinkler systems, and storage facilities. Shows like *Everybody Hates Chris* and *Rizzoli & Isles* have often used this area to film.

"B" TANK, 1995. This view of the "B" Tank shows an enclosure used for controlled water scenes utilizing specialized lighting for weather effects. The outdoor tank and sky backing are important facilities that Paramount offers for film or television production. When not in use, the tank serves as a parking lot.

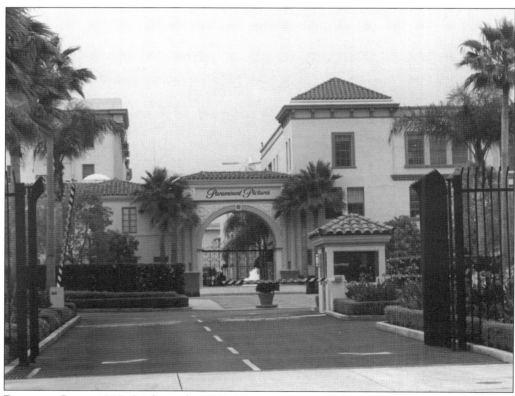

BRONSON GATE, 1995. In the early 1990s, Paramount installed a water fountain at the former intersection of Bronson Avenue and Marathon Street.

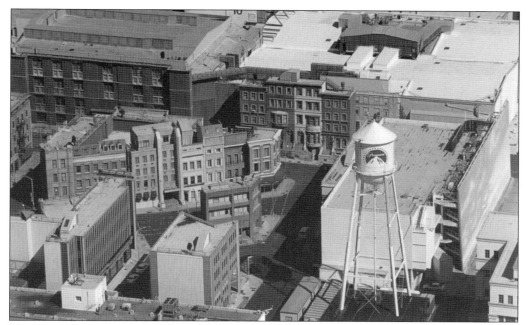

NEW YORK STREET, 1999. This view of the New York Street set shows *The Bronx Zoo* facade on Stage 15, Avenue H fronting Stage 14, Soho, Greenwich Village, Upper East Side, Lower East Side, Washington Square, the modern financial district, Brooklyn and Boston brownstones, and the Film Archive Building attached to the rear of the Sky Backing.

BRONSON GATE, 1996. The iconic Bronson Gate, which has always been known as the alternate company trademark, is seen here—lit at night as it has been for decades. When the gate was built in 1926, the Paramount sign at the top of the arch had a rear-lighting effect. The lights were removed over the years but were restored in the 1990s.

GOWER STREET AUTO AND TRUCK ENTRANCE, 1996. In this photograph, Stages 27 and 28 are visible from the Gower Street truck and auto gate. This entrance serviced the East Paramount lot. This gate was built when RKO expanded their studio lot in 1931, but it was only used by large trucks. When Desilu acquired the studio in 1957, a more active gate was installed for trucks servicing Stages 29 through 32. This was also the entrance to the fictional Woltz International Studios lot in *The Godfather*. When Tom Hagen comes to Hollywood to meet with Jack Woltz in the film, he enters through this gate.

FILM VAULT BUILDING, 1997. These film vaults were built by Paramount in the 1920s, when the editorial building and screening rooms were expanded on the lot. Film vaults were very important, due to the value of the film negatives that were stored there for safe keeping.

FIRE DEPARTMENT BUILDING, 1997. Every studio in Los Angeles has a fire department on its lot, as studio fires are a constant threat. Paramount's fire department facade was installed in the 1990s, when the department had only one small fire truck.

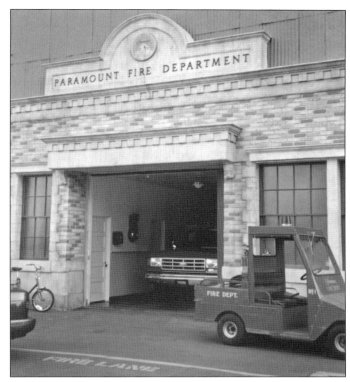

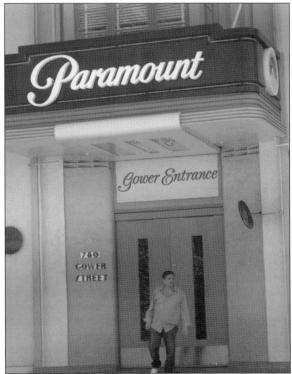

GOWER STREET ENTRANCE, 2000. Coauthor Michael Christaldi is seen leaving the Gower Street pedestrian entrance. This was originally the entrance to the RKO and Desilu administration building and studio lot. This iconic entrance was closed on December 20, 2013. (Photograph by Angela Christaldi.)

DISCOVER THOUSANDS OF LOCAL HISTORY BOOKS FEATURING MILLIONS OF VINTAGE IMAGES

Arcadia Publishing, the leading local history publisher in the United States, is committed to making history accessible and meaningful through publishing books that celebrate and preserve the heritage of America's people and places.

Find more books like this at
www.arcadiapublishing.com

Search for your hometown history, your old stomping grounds, and even your favorite sports team.